IMAGES
*of America*

# TOCCOA

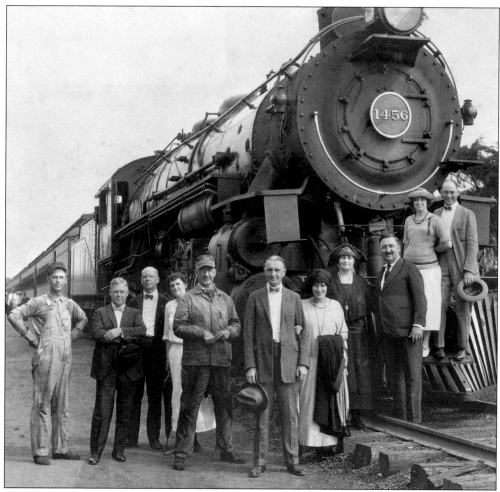

**ON THE COVER:** The completion of the railroad from Atlanta to Toccoa ushered in a new age of industry and growth. In this 1923 photograph, famed Southern Railway engineer David J. Fant (fifth from left) poses in front of his train along with others. Fant was the engineer of the company's Southern Crescent line and over the years earned a place in railroad folklore as being "the evangelist of the rails." He was married to former Toccoa resident Lillian Rainey. Pictured from left to right are the unidentified fireman of Engine Number 1456, Rev. J.S. Hartsfield (pastor of First Baptist Toccoa), Judge and Mrs. McMillin, Fant, Mr. and Mrs. F.F. Bosworth, Evelyn and Dr. Richard A. Forrest, and Mrs. Bosworth and B.B. Bosworth. (Courtesy of the Toccoa Falls College Archives.)

# IMAGES of America

# TOCCOA

Angela Ramage and Kelly Vickers

ARCADIA
PUBLISHING

Published by Arcadia Publishing
Charleston, South Carolina

Printed in the United States of America

Library of Congress Control Number: 2011945484

For all general information, please contact Arcadia Publishing:
Telephone 843-853-2070
Fax 843-853-0044
E-mail sales@arcadiapublishing.com
For customer service and orders:
Toll-Free 1-888-313-2665

Visit us on the Internet at www.arcadiapublishing.com

*This work is dedicated to the memory of the pioneer families who ultimately played an important part in settling the city of Toccoa and the surrounding area that became Stephens County. We also would like to dedicate it to the people of Toccoa, who have chosen to live, work, and raise their families here. They are the ones who continue to make Toccoa a city of hope and promise for future generations.*

# CONTENTS

# ACKNOWLEDGMENTS

In writing *Toccoa*, we have learned a great deal about the city and its historical roots. We also discovered there is a real balance that must be maintained in the selection of photographs that can best tell the story of our community's history. While to some, Toccoa may seem like a small city located in the foothills of northeast Georgia, it is certainly not small when it comes to fascinating people and stories.

Even a short pictorial history like this one cannot be written without acknowledging the interdependence of those who have lived and worked in the communities around us. This is why we have incorporated some of the surrounding communities and people of Stephens County. Ultimately, it is the strength of family ties and valued friendships that define Toccoa as a community rather than a mere dot on a geographical or political landscape.

You also will notice we have chosen to limit the scope of this work to cover the period of the 1800s to the late 1950s. *Toccoa* is by no means an exhaustive historical work, but we do hope you will enjoy what you read and see in this book. In the end, our greatest desire is that you will come away with a new perspective on our past and a joy that comes from revisiting some memories of long ago.

The authors would like to recognize Robert A. Troup for his foresight in taking and preserving for the city many of the images of the downtown area, particularly from the 1950s. Troup took a number of the images from this time period attributed to the Stephens County Historical Society.

We would also like to acknowledge the invaluable contributions of the following individuals and organizations that have helped to make this a fun and enjoyable project: the City of Toccoa, including Connie Tabor, planning and Main Street director; and Sharon Crosby, special events coordinator for Main Street Toccoa; Stephens County Historical Society and the Currahee Military Museum, specifically the following officers: Brenda Carlan, executive director; Cindy Tatum, president; Steve Tilley, second vice president; and Sybil Harber, recording secretary. We would also like to thank Willie Mae Byrd Keels, Kim Hudgins, Marty Heaton, Lamar Davis, Roy Collier, Willie Woodruff, Brenda Ritchey, Howard Farmer, Yeng Her, Ruth Good, the Toccoa Falls College Archives, and Dale Hardy of R.G. LeTourneau Heritage Center and LeTourneau Technologies Inc., Longview, Texas.

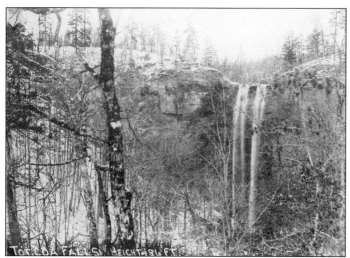

This is the earliest known photograph of Toccoa Falls, taken on a rare snowy day in Toccoa, probably in the 1880s. Toccoa Falls was home to the Cherokee village of Taucoe. Taucoe ceased to exist in the 1750s to 1760s when the village inhabitants were massacred by the Chickasaw tribe from the west on a raid of the Cherokee Lower Towns. (Courtesy of the Toccoa Falls College Archives.)

# INTRODUCTION

Toccoa City was established in 1873 as a coaling stop on the newly laid Atlanta and Richmond Air Line Railroad, which would eventually run between New Orleans and Washington, DC. The particular choice of the area, known as Dry Pond, was made as a result of the railroad's close proximity to Toccoa Falls. For years, tourists and pioneers traveling west had come by way of the Red Hollow Road, Wofford's Road, Jarrett's Bridge Road, and the Unicoi Turnpike to the High Falls of Toccoa. From the earliest accounts, the falls were described as the most beautiful of scenes in the South.

It was no surprise that the very first businesses established near the railroad were hotels to accommodate the overnight guests, and livery stables to transport visitors out to the falls. The founding businessmen named the Dry Pond area Toccoa (Cherokee for "beautiful"), borrowed from the nearby Toccoa Falls. For generations prior to the founding of Toccoa City, this same area was home to the Lower Towns of the Cherokee. Notable towns along the Tugaloo River and its tributaries during this period were Estatoe, Tugaloo, Noyowee, Tetohe, Taucoe, and Eustanali. Other Cherokee towns located in current day Stephens County included Cussatee, Cattuse, Tussee, and Sukehi.

The Lower Towns, especially those along the Tugaloo River Corridor, were a major crossroads in the patchwork of ancient Indian trails through the South. These trails became vital thoroughfares during the Colonial trading period, from 1687 to 1783. Written accounts of traders, Indian agents, and explorers through this area date back as far as 1690. Col. George Chicken, Indian agent, provides detailed accounts of his visits through the Lower Towns in 1715 and again in 1725, specifically mentioning the Cherokee town of Taucoe, which was located at Toccoa Falls, as well as detailed accounts of many of the other towns along the Tugaloo River Corridor.

The Lower Towns along the Tugaloo River Corridor played a central role during the Colonial trading period, as tens of thousands of buckskins were harvested annually, tanned by the Cherokee, and then sent on to Fort Moore (Augusta area) and Charleston, South Carolina, by pack-horsemen. As the colonists continued their encroachment into the hunting grounds and villages of the Lower Towns, the Cherokee, having received guarantees of established boundary lines from King George III in 1763, allied with the British. During the Revolutionary War, the South Carolina and Georgia militias were swift and brutal in their retaliation, burning the Lower Towns, killing the Cherokee, and driving them back to the Middle and Overhill settlements.

Following the Revolution, the Boundary Line, later known as the Hawkins Line, named for Indian agent Benjamin Hawkins who surveyed the line, was established between the Cherokee Nation and the new Franklin County, Georgia. Within the area of current Stephens County, the boundary ran in a straight line between Currahee Mountain and present-day Yonah Dam, passing just above the High Falls.

Revolutionary soldiers and Patriots, many of whom had participated in the decisive Battle of King's Mountain, received bounty land grants for the newly opened Indian lands in the Tugaloo River Valley, in present-day Stephens County. Among some of these earliest settlers were Joshua Gotcher, Col. William Wofford, Major Jesse Walton, James R. Wyly, Col. Benjamin Cleveland, Col. James Blair, John Stonecypher, William Cheek, George Bond, Richard Bond, Capt. James Terrell, John Clarke, John Ramsay, Thomas Payne, Thomas Clarke, and Peter Carnes. Other early families to settle in the newly opened Indian lands included the Whitehead, Hollingsworth, Payne, Yearwood, Dodd, Prather, and Jarrett families.

By 1813, the need was recognized for a road from the Tugaloo River Corridor through to Eastern Tennessee as that area opened for new settlement. Entrepreneur James R. Wyly, along with representatives of the Cherokee and the state of Georgia, worked together to improve the

ancient Unicoi Indian trail as a turnpike by which settlers could be guaranteed safe passage through the Indian Territory to Tennessee. The new Unicoi Turnpike, completed by 1816, began below Traveler's Rest and entered the Cherokee territory at the boundary just above the High Falls.

After a new cession from the Cherokee in 1817, Habersham County was formed out of the Cherokee Territory and Franklin County in 1818. By the 1840s, three post offices show the centers of population in what later became Stephens—Walton's Ford on the Tugaloo, Currahee Mountain, and Toccoa Falls. By the time of the Civil War, the area around the intersection of the Red Hollow and Jarrett's Bridge Roads (current downtown area of Toccoa) became known as Dry Pond, and it was here that in 1861 the soldiers mustered for duty for the War between the States. The *Toccoa Record*, later remembering this sad occasion, recorded that families and friends gathered as a Confederate band played Southern anthems. The war years, and those that followed, were difficult for those who lived in this area.

Although there was little other development, shortly after the war's end, Archer Whitehead operated a general store at the Dry Pond crossroads that later may have become known as Henderson's. The store gained notoriety when later, as property was being sold, the owner would simply put logs under it and roll it to another lot.

With the approach of the railroad in 1871, three enterprising businessmen, Dr. Oliver M. Doyle of Oconee, South Carolina, and B.Y. Sage and Thomas Alexander of Atlanta, began purchasing the land surrounding Dry Pond. Lots were surveyed and plans were made for their sale in an auction to be held May 27, 1873. Investors arrived in excursion trains from Atlanta, and although the auction had to be postponed shortly after beginning due to heavy storms, the lots continued to sell for the next two years.

In April 1874, Habersham County granted a charter of incorporation for the town of Toccoa City, which was laid out two miles square. As elections were held, growth came quickly to the fledgling town. In addition to the hotels, livery stables, banks, churches, barrooms, schools, stores, and businesses were soon established. By 1880, the population of Toccoa City was 900 and by 1900, it had swelled to 2,800 citizens. The town's charter was amended in 1899 to change its name to the City of Toccoa, known simply as Toccoa.

As Toccoa's growth surpassed that of Habersham County's seat of Clarkesville, a growing sense of alienation and neglect by county officials was felt by the citizens of Toccoa, and a formal campaign was organized to become the new county seat. Tensions ran high in this debate, and when this campaign narrowly failed, the Clarkesville courthouse was mysteriously blown up. The citizens then refocused their efforts to form a new county with Toccoa as the county seat. Approval finally came on August 18, 1905, and Stephens County, named for vice president of the Confederacy Alexander Hamilton Stephens, was formed out of portions of Habersham, Franklin, and Banks Counties. Stephens County boasted a population of 9,000 at its formation and comprises 163 square miles.

The new Stephens County courthouse was soon constructed. Also, by this time, Toccoa had become the cotton center for the surrounding counties. Waterworks, electricity, and telephone services were major additions during this time, and a period of growth was realized as new churches and schools were organized. In addition to cotton, businesses included banks, furniture factories, an oil mill, fertilizer factory, brickyard, icehouse, bottling works, tannery, harness factory, rock quarry, and hotels. By 1914, Toccoa's population had exceeded 4,000.

Although the coming of the railroad and the genius of its founders established Toccoa as the new hub for growth in northeast Georgia, many individuals and the surrounding communities provided the needed backdrop for the family ties, lasting friendships, and commercial growth that came so quickly to the new county. Historic communities included in the territory of the new county included Akin, Avalon, Ayersville, Bending Hickory, Boydville, Carnes Creek, Currahee, Deercourt, Dry Pond, Eastanolle, Ester, Hayes Crossing, Leatherwood, Martin, Mize, Mountain Grove, Nancy Town, New Switzerland, Pole Cat, Toccoa Falls, Tournapull, Tugalo, Walton's Ford, and Wolf Pit.

In 1911, Dr. R.A. Forrest purchased the famous Haddock Inn and 100 acres, including Toccoa Falls, from Toccoa businessman E. Palmer Simpson, and established Toccoa Falls Institute, which continues to this day as Toccoa Falls College.

Greater need for regional electric power brought about the construction of Yonah Dam from 1924 to 1925, employing hundreds of local citizens for these years. A small railroad, known as the Dinky Line, was built from Tugaloo Station to Yonah Dam for transport of the materials needed for the project.

The city and the county continued to experience rapid growth throughout the next decade, but following World War I, the local economy began to slow, particularly among agricultural communities. By 1929, the Great Depression brought about the failure of banks, businesses, and jobs. A number of federal assistance programs were developed in the 1930s, which helped the local economy and had a lasting impact in the county. The Civilian Conservation Corps (CCC), National Youth Administration (NYA), Works Progress Administration (WPA), Rural Electrification Administration (REA), and Farm Security Administration (FSA) all provided employment, job training, education, and financial assistance to the county.

Between 1937 and 1941, the federal government, under the Resettlement Act, established the Lake Russell Wildlife Management Reserve (LRWMR) in the southwestern part of the county, and in so doing, forced the removal of the following long-established communities: Ayersville, Currahee, Leatherwood, Mountain Grove, Nancy Town, and New Switzerland. The Lake Russell area, as part of the developing Chattahoochee National Forrest, was to become a wildlife and timber management area, and a potential site for a military base.

Considered to be the father of the modern earthmoving industry, inventor and industrialist R.G. LeTourneau came to Toccoa in 1938. Throughout the war years, LeTourneau built a large earthmoving equipment factory and established the multifaceted 5,500-acre community of Tournapull, employing hundreds of Stephens County citizens. During World War II, the LeTourneau plant produced 70 percent of the heavy earthmoving equipment used by the Allies, as well as close to one million 155-millimeter artillery shells.

Camp Robert Toombs was soon established at Currahee Mountain for summer training of the Georgia National Guard. However, by 1942, the US Army's first airborne divisions were organized, and the 506th Parachute Infantry Division of 5,000 men activated at Camp Robert Toombs. Col. Robert Sink, commander of the 506th Easy Company (made famous in the Stephen Ambrose book *Band of Brothers* and the miniseries of the same name) requested and was granted a change of name to Camp Toccoa.

Following the war, Toccoa again experienced significant industrial and economic growth, remaining the hub of county activity. R.G. LeTourneau's coming to Toccoa spurred numerous businesses and industries to spring up, with new industry replacing much of the prior agricultural activity. One thing that has remained consistent, regardless of growth and change, is the desire of Toccoa's citizens to have a place where folks feel welcome and at home. It is the city's families, friendships, and relationships that make Toccoa one of the best places in Georgia to visit, live, work, and play.

The Unicoi Turnpike was constructed from 1813 to 1816 as a joint project between the Cherokee and the state of Georgia. It began near Traveler's Rest and passed just above Toccoa Falls as it crossed into Cherokee territory on its way to newly settled areas in Eastern Tennessee. Thousands of pioneers traveled the Unicoi Road, as it was referred to in the earliest maps of Habersham County. This photograph is of a particularly beautiful section of the Unicoi Turnpike above Toccoa Falls. (Courtesy of Kelly Vickers.)

# One

# In Olden Times

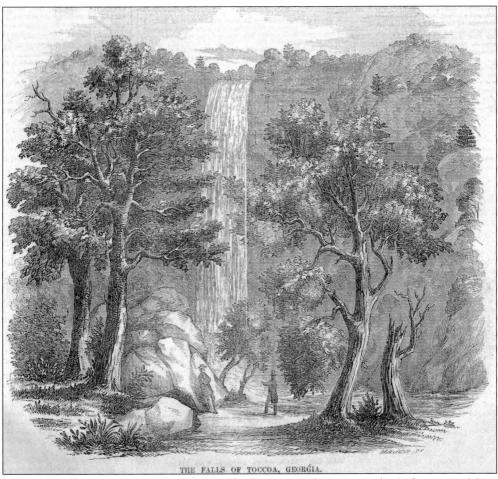

THE FALLS OF TOCCOA, GEORGIA.

The High Falls of Toccoa attracted thousands of visitors and tourists in the 19th century. Many expressed their wonder of its beauty through prose, poetry, and art. Particularly, a number of steel and wood engravings were made of the great High Falls in the period from 1835 to 1885. This 1854 engraving includes a representation of two tourists. (Courtesy of Angela Ramage.)

Indian Springs and Garnet Springs, both natural mineral springs adjacent to the old village of Taucoe, were popular wayside stops for refreshment along the old Unicoi Road on the way to the High Falls of Toccoa. These early 1900s photographs show visitors getting refreshment from the springs. Above, remnants of ancient petroglyphs can still be seen above the Indian Springs entrance, referenced on the back of the photograph. In the 1897 photograph below, Garnet Springs, named for the garnets found there, was a popular mineral spring in this region prized for its therapeutic value. Pictured from left to right are Rena Gallagher, Mace, Kate, George, Mrs. Cooper, and Bird. Both Indian Springs and Garnet Springs are located on the campus of Toccoa Falls College. (Courtesy of the Toccoa Falls College Archives.)

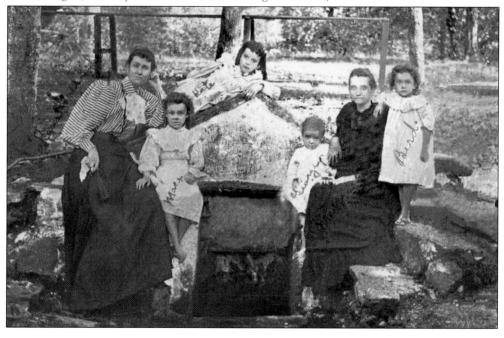

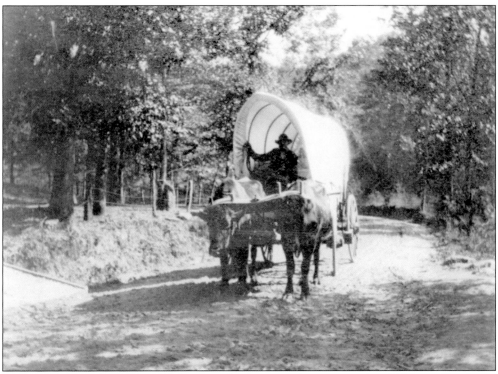

This early 1900s photograph shows an ox-drawn covered wagon on the old Unicoi Road near Toccoa Falls. It is typical of the thousands of pioneers who traveled the Unicoi through the Cherokee territory 100 years earlier. (Courtesy of the Toccoa Falls College Archives.)

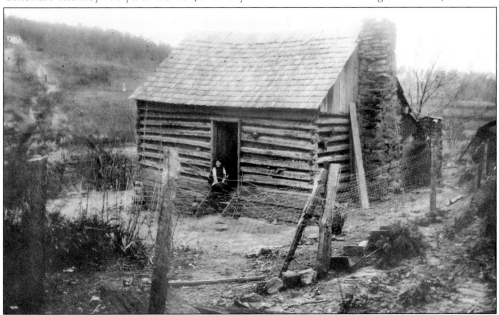

This cabin of Jim Ballew was located northwest of Toccoa Falls. It is typical of small, early mountain cabin homes that families carved out of the wilderness. (Courtesy of the Toccoa Falls College Archives.)

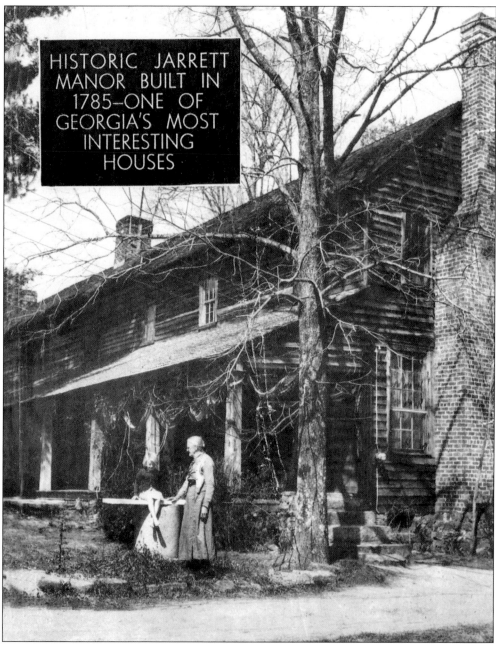

HISTORIC JARRETT
MANOR BUILT IN
1785—ONE OF
GEORGIA'S MOST
INTERESTING
HOUSES

One of the first land grants in the Tugaloo River valley, following the Revolution, was made to Maj. Jesse Walton in 1784. After being ambushed by a nearby Creek raiding party, Major Walton's widow sold the homestead to her brother Joseph Martin, who in turn sold it for $2,000 to the enterprising James Wyly around 1800. By 1815, Wyly had replaced the old Walton homestead with the current southern end of the Traveler's Rest Stagecoach Inn, one of four inns built along the Unicoi Turnpike, and the only one surviving to this day. In 1833, Devereaux Jarrett purchased the Traveler's Rest Inn and expanded its services by adding the northern end of the house, doubling its size. Until Jarrett's death in 1852, Traveler's Rest served as headquarters for his expanding 14,400-acre plantation and related businesses. (Courtesy of the Stephens County Historical Society.)

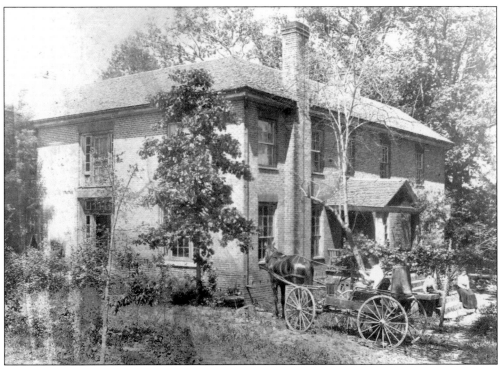

When Devereaux Jarrett died in 1852, his plantation was divided amongst his four heirs. This is the home of Thomas Patton Jarrett, son of Devereaux Jarrett. (Courtesy of the Stephens County Historical Society.)

Currahee Mountain is the last of the Blue Ridge Mountain chain. It stands 1,735 feet above sea level and rises 900 conical feet above the plains below. Currahee has been translated from the Cherokee as "stands alone." With its significant landscape, it was an attraction for settlers from the earliest days. Numerous mines, dug by both the Indians and the early settlers, yielded rubies, garnet, silver, and gold. A number of communities developed in the shadow of Currahee, and a post office was established as early as 1836. (Courtesy of the Stephens County Historical Society.)

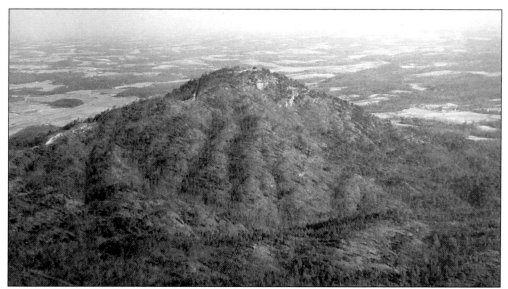

This aerial photograph of Currahee Mountain, facing north, was taken around 1946 as part of a survey before the Federal Communications Commission could issue a license for radio station WLET. Note the road to the top of Currahee along the ridge to the left. A portion of the soldiers' training routine at Camp Toccoa during World War II involved running the three miles up and three miles down the mountain. (Courtesy of the Stephens County Historical Society and the Virgle Craig family.)

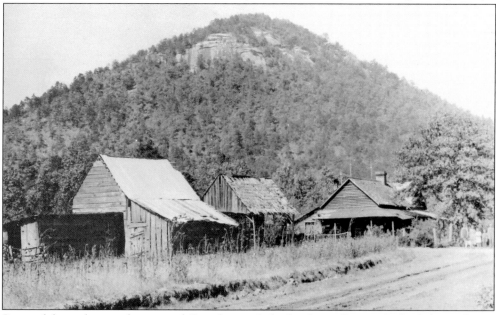

Some of the earliest settlers around Currahee include the Ayers, Brown, Cash, Colston, Dean, Edmonds, Farmer, Fricks, Kelley, Kimbrell, Lathan, Naves, Norton, Payne, Pless, Reynolds, Savage, Simmons, Stephens, Thomason, Umberhant, and Wetphal families. This photograph shows the Tom and Henry Holcomb homestead at the base of Currahee Mountain. As farmers, families in the Currahee communities were for the most part self-sufficient. When needed, they would take their wagons into Toccoa to purchase flour, salt, sugar, coffee beans, and other ingredients for baking. (Courtesy of the Stephens County Historical Society.)

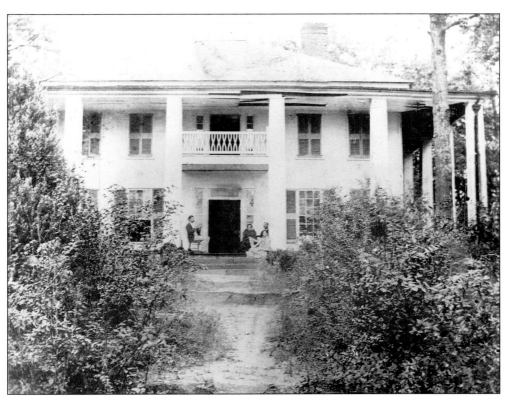

Riverside, a twelve-columned antebellum home along the upper Tugaloo River Corridor, was built by James Wallace Prather and his son Joseph Jeremiah Prather in the early 1850s. In April 1865, Riverside played an interesting role in the Civil War when Confederate general Robert Toombs, a friend of Joseph Jeremiah Prather, hid in an upstairs closet to escape arrest by the Union Army following the assassination of Pres. Abraham Lincoln. (Courtesy of the Stephens County Historical Society.)

This log cabin is actually the original home of James Wallace Prather after he moved to this area as early as 1802. A later home had been built around it, which helped to preserve the cabin until it was eventually restored and moved across the road to its present location at Riverside. Descendants of the Prathers' slaves occasionally still gather for reunions at Riverside or a local park. (Courtesy of the Stephens County Historical Society.)

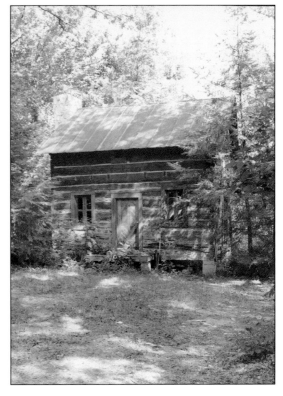

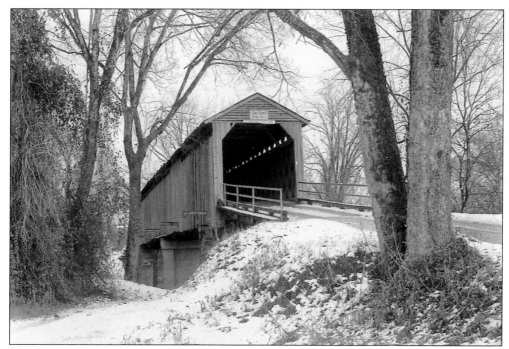

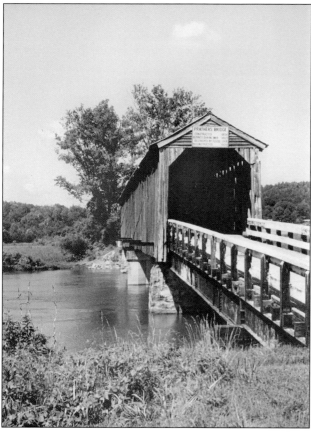

The first Prather Bridge was constructed by James Wallace Prather in 1804, shortly after purchasing over 1,000 acres along the Tugaloo River. Until this time, either fords or ferries crossed the river. After being damaged by frequent flooding, Prather Bridge was rebuilt in 1850, 1868, and 1920. The photograph above was taken from the Georgia side on a snowy day, while the photograph at left was taken sometime later from the South Carolina side. In the distance to the left of Prather Bridge, the Riverside Mansion is visible through the trees. Prather Bridge was destroyed by fire in 1978. (Above, photograph by Bob Daniel; courtesy of Chris Daniel; left, photograph by Forrest Shropshire, gift from Betty Hitt Swords to Stephens County Historical Society, courtesy of the Stephens County Historical Society.)

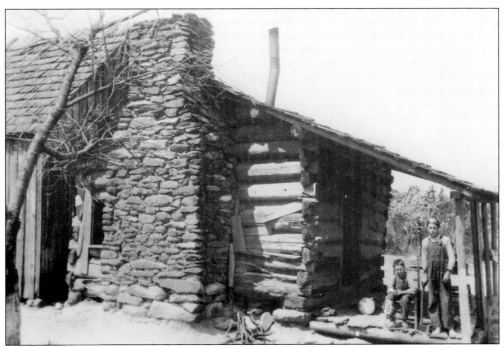

The Ansley Simmons log cabin, pictured above, is typical of many rural homesteads. This photograph catches the older boy in the midst of his chores. Note the ax. Below, the Weaver-Finley homestead was located near Panther Creek. The boys pictured are Joe Finley (left) and Carl Finley. Note the combination log cabin, batten board, and wood-shake siding. On each homestead, note the stacked rock chimney and the stovepipe from the roof. This would indicate a wood-burning stove for cooking and heat, in addition to the fireplace. In the photograph below, note the freshly tilled garden in close proximity to the house. (Courtesy of the Stephens County Historical Society.)

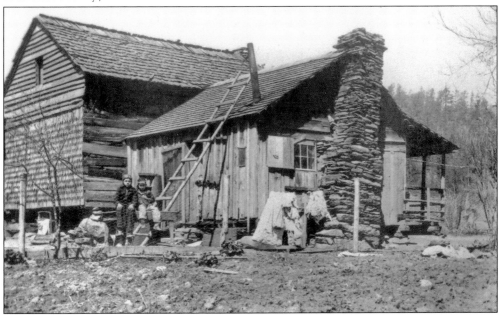

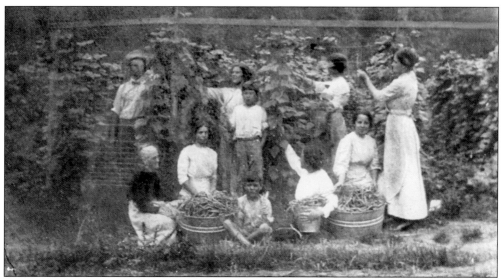

Families worked together in their fields and gardens to provide plenty of vegetables for canning. (Courtesy of the Toccoa Falls College Archives.)

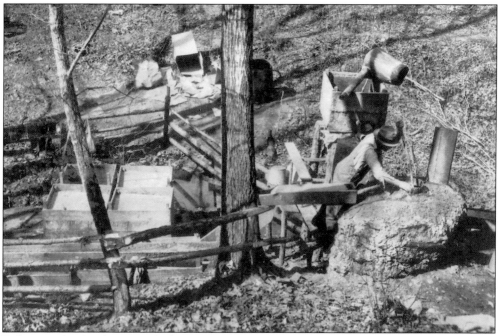

Following the Civil War, with the economy in a shambles, many of the mountain and rural folks turned to converting corn into liquid form as a source of income. The liquor from certain parts of the county brought a premium price as far away as Atlanta. From the Tugaloo corridor area, Channing Hayes recounts, "When we were working on the barns, Grandaddy and I would eat our lunch at the 'spout spring.' There was a large area round the spring and enough trees to provide shade before the highway was built. This was a favorite resting place in olden times for people from Panther Creek, Brass Town, and the upper Tugaloo. It was said that 'there was more corn likker drunk there than arie place in Georgia.'" (Courtesy of the Stephens County Historical Society.)

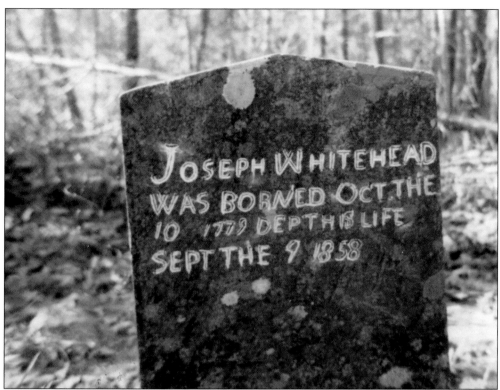

Joseph and Anna Whitehead were among the earliest settlers in the Bending Hickory area above Toccoa Falls on the Boundary. These tombstones are in a cemetery adjacent to the old Unicoi Road, which passed by just below their homestead. (Courtesy of the Toccoa Falls College Archives.)

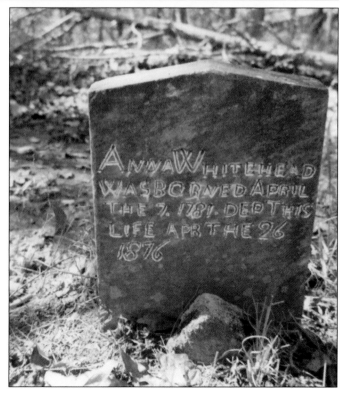

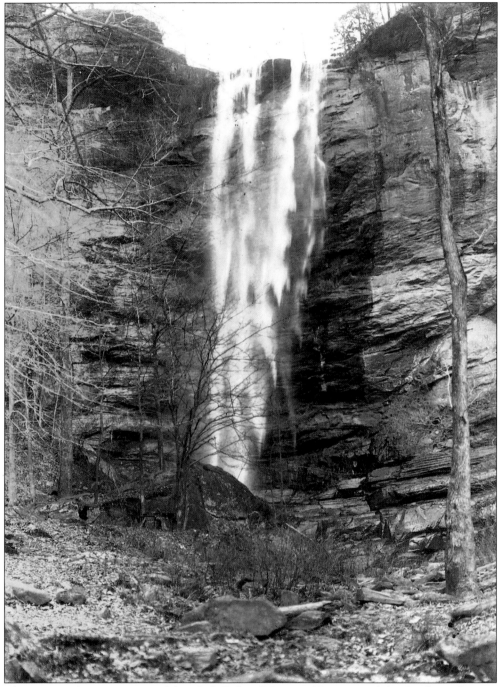
This is an early winter view of the High Falls of Toccoa. (Courtesy of the Stephens County Historical Society.)

# Two

# FOUNDING OF A CITY

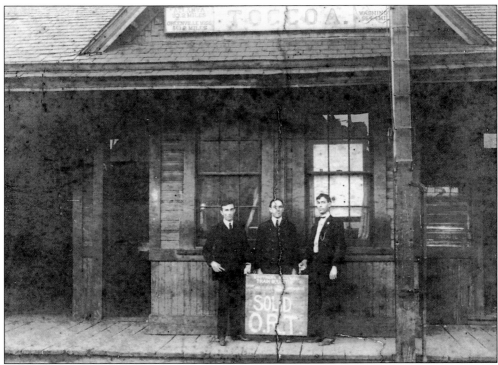

Toccoa City's founding businessmen, Dr. Oliver M. Doyle of Oconee, South Carolina, and B.Y. Sage and Thomas Alexander of Atlanta, pose for a picture at the train depot. This photograph may date from the 1880s, given their still-youthful appearance. Approximately one year following the May 27, 1873, auction, a visitor from Anderson, South Carolina, recorded, "We reached Toccoa City in good order and fine spirits. We were, however, very much struck by the fact that Anderson should be called a village, while these half a dozen white houses stuck on the side of the railroad are called a city. We must remember this is a fast age." And what a fast age it was for the fledgling Toccoa City. Only one year later, the *Atlanta Constitution* notes, "this is a remarkable little town. Two years ago there was scarcely a house on the place. Now some twenty or thirty substantial and beautiful business houses are erected and full of goods, and improvements are steadily going on. The town has four good hotels, three saw mills, three good livery stables and other attractive features. The population is, we think, about 1,200. There is steady improvement. New buildings are going up—brick are being made by the thousands, and much lumber is being sawed. This place will eventually be quite a city." (Courtesy of the Stephens County Historical Society.)

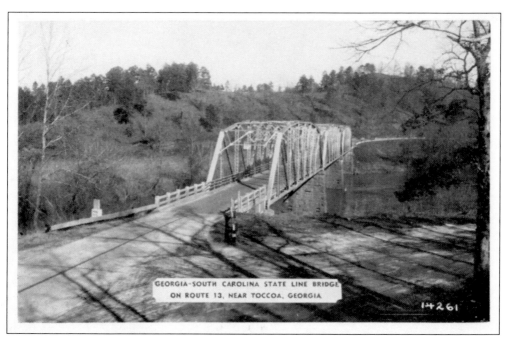

GEORGIA-SOUTH CAROLINA STATE LINE BRIDGE
ON ROUTE 13, NEAR TOCCOA, GEORGIA

14261

The area now locally known as Broken Bridges was once the original railway trestle across the Tugaloo River, linking Toccoa to Westminster, South Carolina, and completed late in 1873. After the railroad was rerouted a mile to the west and a new trestle built in 1918, the old train trestle became the Highway 123 bridge. When Highway 123 was later rerouted a half mile to the west, the center section was removed and Broken Bridges was left for recreational use. (Courtesy of Kelly Vickers.)

Capt. Andrew H. Ramsay (brother-in-law to Dr. Oliver M. Doyle) and his wife, Sally Azalea Jarrett (granddaughter of Devereaux Jarrett) had the distinction of being the parents of the first child born in Toccoa. Captain Ramsay was a civil engineer, helping to build the railroad. He purchased one of the first lots in the auction, helped to organize the Presbyterian church in Toccoa, and served in a variety of leadership capacities in the new city. (Courtesy of the Stephens County Historical Society.)

Doyle Street was a bit wider in the 1880s. (Courtesy of the Stephens County Historical Society.)

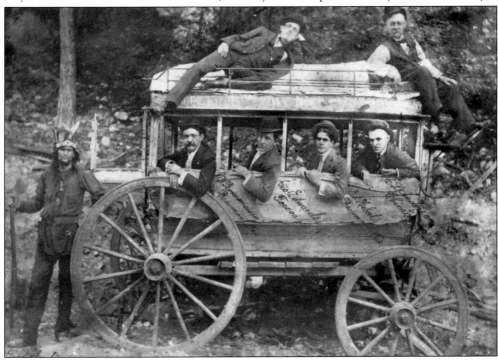

This stagecoach was visiting Toccoa in the early 1890s. The stagecoach reads at the top, "Used by Jesse James Near Hot Springs AR 1868," and the following men are named: Edwin Hebert and Dominique Bonnemaison of Beaumont, Texas; George Edwards of Toccoa; and C.L. Anderson of Chicago, Illinois. George Washington Edwards was a leading businessman in Toccoa in the 1880s through the 1920s. (Photograph donated to the Toccoa Falls College Archives by Mrs. Caroline Cooper Edwards Lipscomb, daughter of George Edwards; courtesy of the Toccoa Falls College Archives.)

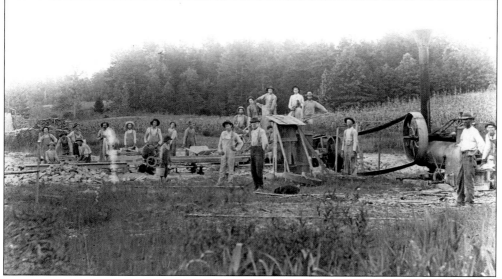

The Hitt Brickyard, owned and operated by building contractor George W. Hitt, was located near Pond Street and Collins Road. All of the buildings in old Toccoa were built of brick from this brickyard. (Courtesy of the Stephens County Historical Society.)

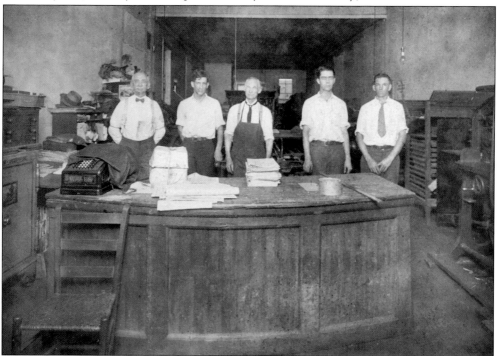

The *Toccoa Record* was established in 1874 and has operated under the names *Northeast Georgia Herald, Toccoa Herald, Toccoa News,* and *Toccoa Record.* This photograph was taken about 1928 in the same building that the *Toccoa Record* currently occupies. James F. Little is second from the right. The other men are unidentified, but the man at far right is believed to be R.W. Graves, who was owner and editor after his father, Edward H. Graves. (Courtesy of Tom Law and the *Toccoa Record.*)

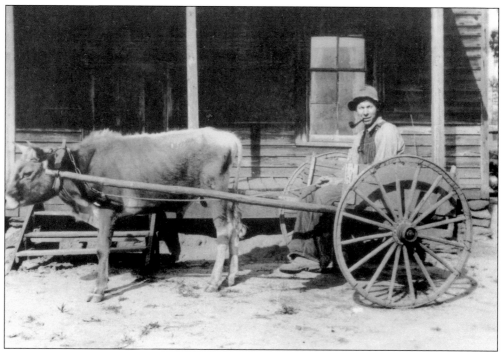

In the early years, the ox-drawn cart was a familiar form of travel, especially in mountainous areas. Here, Albert Blalock readies for the trip to town in style. Blalock operated a sorghum sugar cane mill for the production of syrup. Syrup was often used as a substitute for sugar at the dinner table. (Courtesy of the Stephens County Historical Society.)

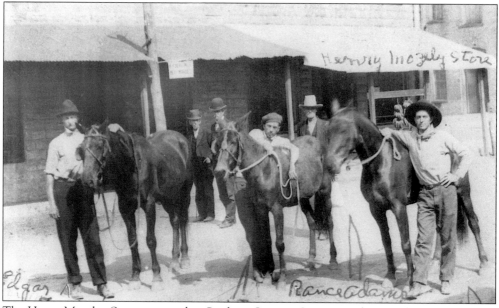

The Henry Mozeley Store, as noted in *Stephens County, Georgia, and Its People*, was located on Pond Street near the bridge. The gentlemen noted in the photograph are, from left to right, Edgar Fryer, E. Mitchel, W.F. Walters, Rance Adams, and Thomas Davis. (Courtesy of the Stephens County Historical Society.)

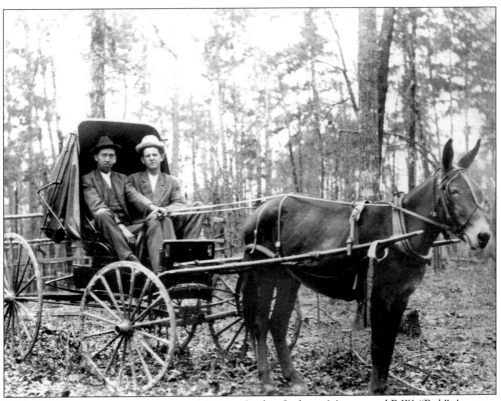

Luther Jackson Murray and R.W. "Bob" Acree are pictured here in 1912 in a mule-drawn carriage typical of the times. (Courtesy of the Stephens County Historical Society.)

The Presbyterian Church was organized by Capt. Andrew Ramsay in 1874, and moved into its first sanctuary on Tugaloo and Pond Streets by 1880. It also had a mission Sunday school, located in the cotton warehouse adjacent to the Toccoa Cotton Mill. In 1925, Dr. R.A. Forrest became the church's pastor. That same year, ground was broken for a new sanctuary with dedication ceremonies in 1926. (Courtesy of Kelly Vickers.)

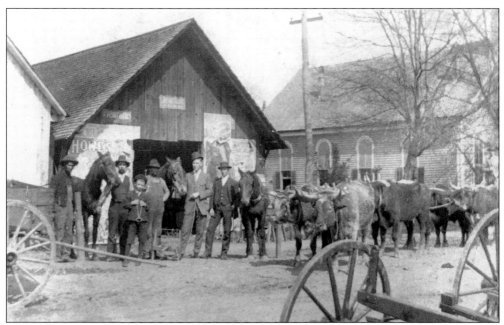

Noah Lafayette Garland, second from left above, moved to Toccoa in 1893 and built a strong livery stable business, which included a taxi service and blacksmith shop. He also rented buggies, two-seated surreys, and three and four seat hacks. As the horse and buggy era faded, Garland sold Ford, Chevrolet, and Oakland automobiles, the latter manufactured from 1907 to 1909. Garland also owned and operated service stations in the area. In the 1895 issue of the *Toccoa News*, an advertisement stated that Hogsed and Garland would take parties in hack loads or small carriages to Tallulah Falls and back for $1. These livery stables were located on the north side of Tugalo, between Pond and Sage. The Presbyterian church can be seen in the background. (Above, courtesy of the Toccoa Falls College Archives; below, courtesy of Roy Collier.)

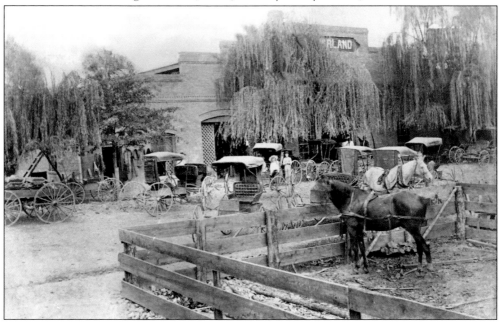

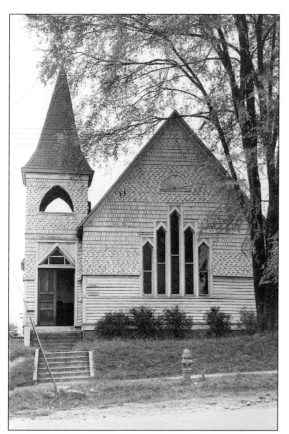

St. Matthias' Episcopal Church first met in the home of Edward Schaefer, and then in the First Methodist Church building. By 1896, Schaefer had donated the property on the corner of Currahee and Alexander Streets. The Carpenter's Gothic–style building was used until it was sold; a new building was completed in 1948. (Courtesy of the Stephens County Historical Society.)

Friendship Baptist Church was one of the earliest black churches in the Toccoa area. It was organized in 1887 and later moved to its current site on the corner of South Sage and Sautee Streets in 1919. (Courtesy of the Stephens County Historical Society.)

Edward Palmer "Pam" Simpson was a leading citizen in Toccoa and an enterprising businessman. In addition to being president of the First National Bank, Simpson owned a real estate and lumber company, operated a general supplies store, and promoted the growth of Toccoa in many ways. In this portrait he appears with his son E.P. Simpson Jr. (Courtesy of the Toccoa Falls College Archives.)

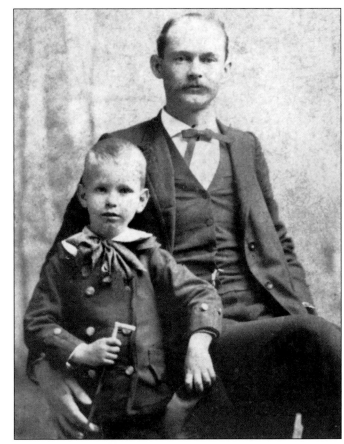

The E.P. Simpson home was one of the earliest in Toccoa. It was located on the corner of Alexander and Savannah Streets. The home was later used as the Toccoa Clinic from 1947 to 1957. (Courtesy of the Stephens County Historical Society.)

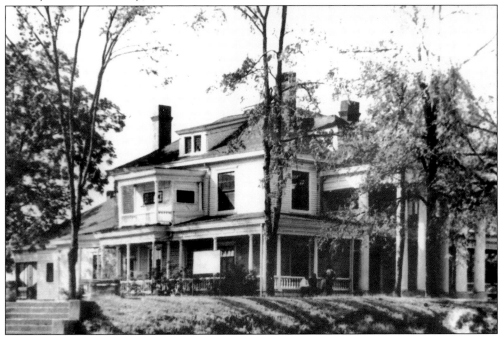

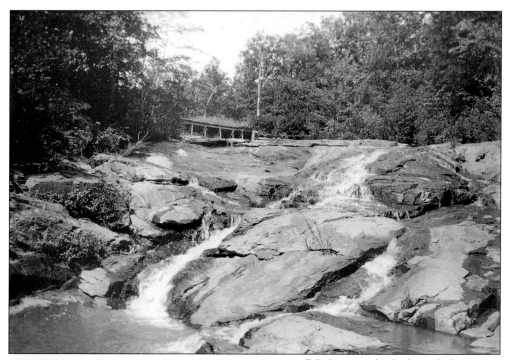

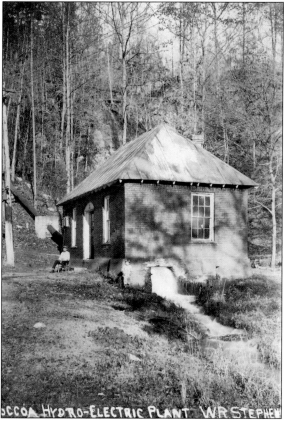

OCCOA HYDRO-ELECTRIC PLANT W.R.STEPHEN

E.P. Simpson built the crib dam seen above to provide power to his new power plant at Toccoa Falls in 1898. The crib dam was located above the rapids at Glenn Falls one half mile above Toccoa Falls, and became the later foundation for the Kelly Barnes Dam. Power from this plant provided electricity to the Haddock Inn and provided the city of Toccoa with its first electricity. (Courtesy of the Toccoa Falls College Archives.)

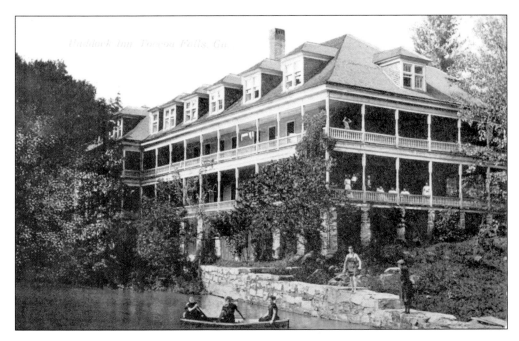

E.P. Simpson began construction of the pond and Haddock Inn in 1898. With 58 large rooms, 750 feet of wide veranda, running hot and cold water, and a direct view of Toccoa Falls, Haddock Inn quickly became a prime tourist destination for many in Atlanta and other places. Later, desiring to see a school established, E.P. Simpson sold the inn and 100 acres, including the Toccoa Falls, to Dr. R.A. Forrest for $25,000 in 1911, and Toccoa Falls Institute was born. Unfortunately, the inn burned to the ground in 1913. Below is a porch scene of the Haddock Inn. (Courtesy of Kelly Vickers.)

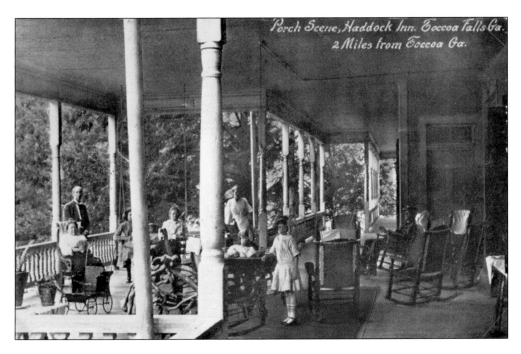

This photograph of a typical street scene in the early 1900s includes Fred Raymond Terrell as a young man. Fred and his wife, Margaret Ruth Dean, later owned and managed a grocery, the Eagle Café, a service station, and Terrell's Café, and served in many civic roles for Toccoa. (Courtesy of the Stephens County Historical Society.)

This 1920 photograph of the railroad tracks includes the Toccoa Grocery, Sprinkle and Isbell's Cotton, Fricks Motors, and one of Charles H. Dance's many ventures. One of the earliest coal and wood yards was owned by Charles Dance and Noah Garland. Later, Dance opened the first ice storage plants on East Currahee Street. He soon combined his ice business with his coal business to form the Toccoa Ice and Coal Company. (Courtesy of the Stephens County Historical Society.)

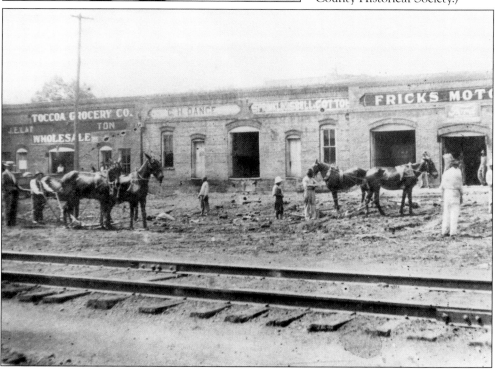

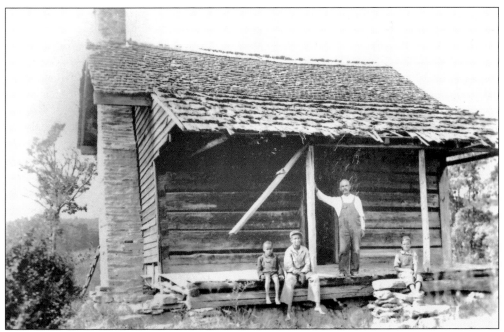

Pictured here on the porch from left to right, Jeff, Snooks, Cliff, and Bertha lived in this log home near Panther Creek. Cliff sold eggs to the workers building the Yonah Dam (1924–1925) and operated a shanty car on the Dinky Line railroad track. His one-car train ran from Yonah Dam to Tugalo Station. Mrs. John Paul Johns said, "We could ride the train to Tugalo and catch the Southern to Toccoa to go shopping." (Courtesy of the Stephens County Historical Society.)

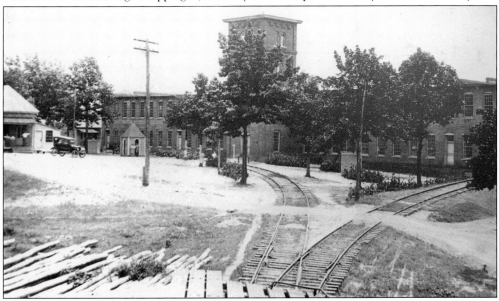

The Toccoa Cotton Mill was the first large industry to begin operation in Toccoa (1897); the principal investors were Edward Schaefer, E.E. Mitchell, and T.A. Capps. By 1916, the mill employed 160 and boasted 8,000 spindles and 256 weaving looms. T.A. Capps later started a second cotton mill, which was eventually sold to J. and P. Coats, later known as Coats and Clark. (Courtesy of the Stephens County Historical Society.)

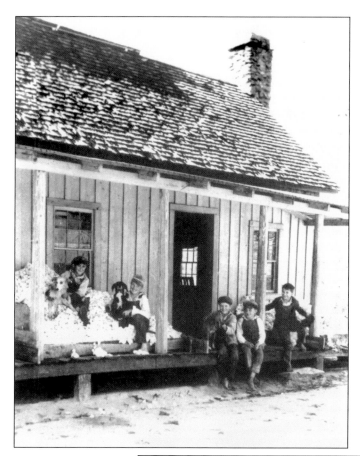

Farmers who raised cotton often stored the "un-ginned" portions in barns and sheds. In this photograph, the cotton is being stored on the front porch, while at the same time providing a comfortable seat for these children and their dogs. (Courtesy of the Stephens County Historical Society.)

With the cotton mill in Toccoa, cotton became a principal crop for many in the county. This photograph contains at least three familiar Toccoa residents. In the back row on the left are Jesse Lee Sullens and Tom Sullens. Evelyn Forrest is wearing a straw hat. (Courtesy of the Toccoa Falls College Archives.)

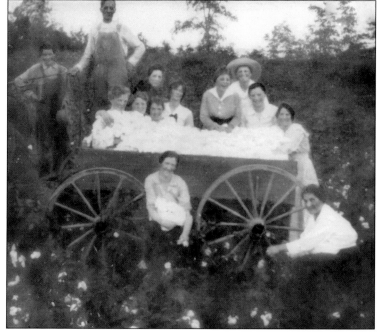

John H. Burton, who was famous for bringing the first bale of cotton to mill, is shown here in his favorite position—high atop a cotton bale. (Courtesy of the Stephens County Historical Society.)

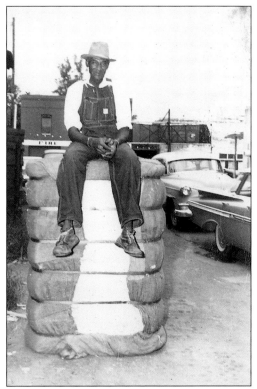

In the late 1800s, agriculture was the cornerstone of economic stability in the south and the same was true for Toccoa. Cotton truly was "king." About 80,000 bales of cotton were processed in Toccoa annually. During the first 70 years of Toccoa's existence, the economic balance was 95 percent agriculture and five percent industry and business. However, by the mid 1900s, this had changed as industry began to rise. (Courtesy of the Stephens County Historical Society.)

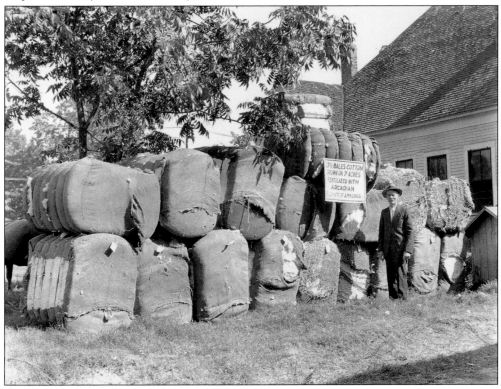

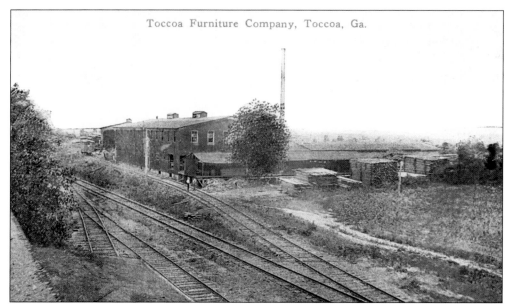

Furniture making was one of Toccoa's earliest industries. J.B. Simmons was the first known furniture manufacturer, setting up his business prior to 1893. W.C. Edwards worked with Simmons and in 1907 opened Toccoa Furniture Company, one of many very profitable enterprises. (Courtesy of Sybil Harber.)

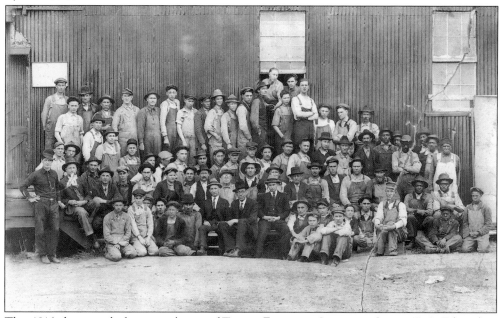

This 1916 photograph shows employees of Toccoa Furniture Company. Owner W.C. Edwards is seated in the center of the front row. To the left of Edwards is Hoke Smith, secretary and treasurer. Harry Hayworth, the third person from left in the second row, later developed his own companies, the Toccoa Novelty Manufacturing Company in 1932 and the Imperial Manufacturing Company in 1938. These companies made a variety of wood furniture, including spinning wheels, ladder-back chairs, secretaries, and living room and bedroom furniture, using walnut, mahogany, and poplar. (Courtesy of Sybil Harber.)

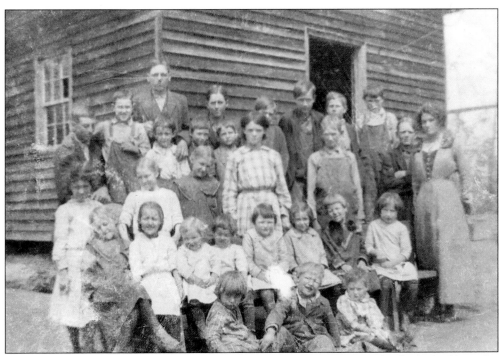

This is a very early photograph of the students of the Mountain Grove School. The building also was the meeting place for the Mountain Grove Church. (Courtesy of Steve Tilley.)

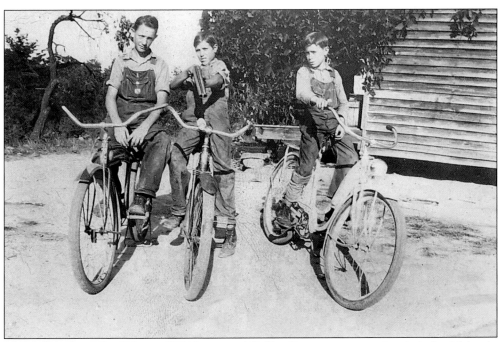

These three boys, Fred Norris, J.W. Norris, and Bobby Carter, seem to enjoy their day biking in their community, especially the one in the center taking aim with his double-barreled shotgun. (Courtesy of the Norris family.)

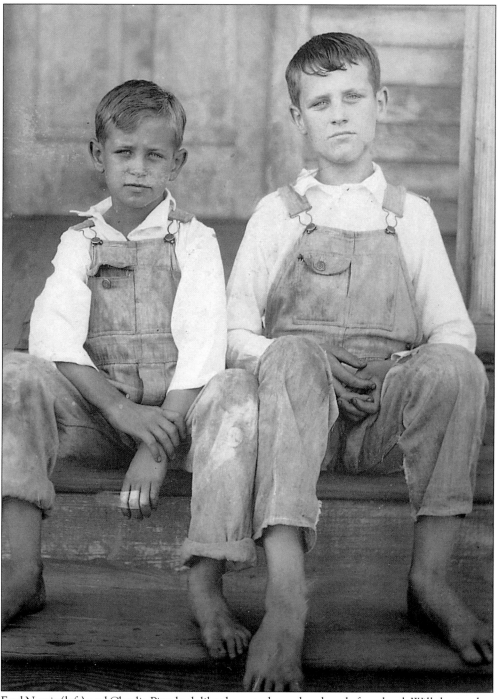

Fred Norris (left) and Charlie Pitts look like they are dressed and ready for school. Will the teacher be ready for them? (Courtesy of the Norris family.)

Union Church and School was located above Yonah Dam on Panther Creek and was sometimes referred to as the Panther Creek Teacher School. The elementary school was a one-room structure like most early schools in the county. The church and school were established in 1850 but moved when Yonah Dam was built in 1925. In this photograph, the teacher is standing on the left. Standing to the right are Grace Rudeseal Holbrooks and Bud Rudeseal. The front row includes Owen Rudeseal and Lottie Rudeseal Ellard. (Courtesy of the Stephens County Historical Society.)

The old Toccoa Colored High School, pictured here, may have been located at or near the location of the Whitman Street School, which had replaced it by 1951. It may also be the Toccoa Colored Industrial College, which was located on Broad Street at the Elberton railroad tracks and referred to in 1906 in the *Toccoa Record*. (Courtesy of the Stephens County Historical Society.)

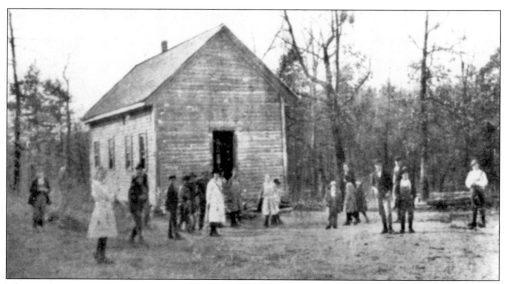

The earliest records indicate the Bending Hickory School was more than likely founded sometime before 1899. The building was a one-room, one-teacher school with seven grades. The structure burned in the early 1930s and was never rebuilt. It was located on Highway 17 one mile north of the Toccoa waterworks. In 1922, there were 30 pupils. (Courtesy of the Toccoa Falls College Archives.)

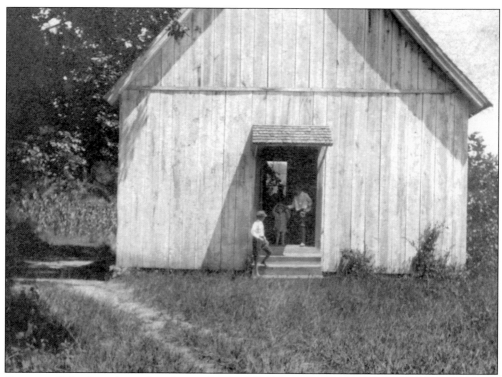

Soapstone School was located on the north side of Highway 17 across from the current Toccoa Creek Baptist Church and operated in the years 1899 to 1922. Soapstone served as both a schoolhouse and Baptist chapel. (Courtesy of the Toccoa Falls College Archives.)

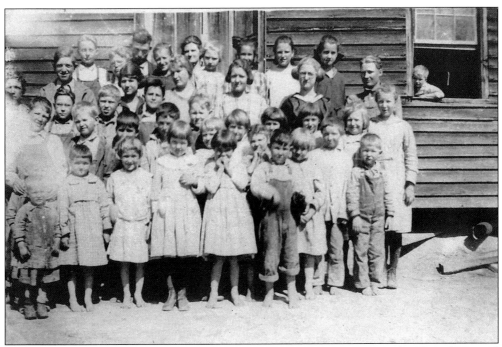

The Mountain Grove Church, as was common with many of the community churches, also served as the Mountain Grove School. This school photograph was taken in the 1920s. The Mountain Grove School included grades one through six. (Courtesy of Steve Tilley.)

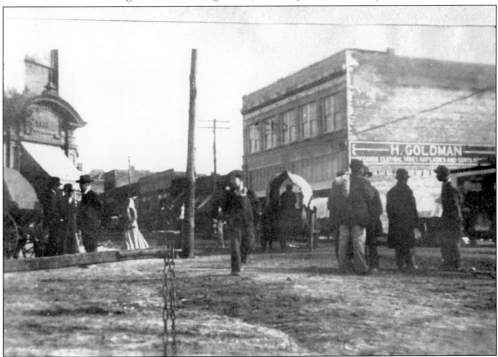

This early photograph of the corner of Doyle and Sage Streets reveals a busy day downtown on the still dirt roads. (Courtesy of the Stephens County Historical Society.)

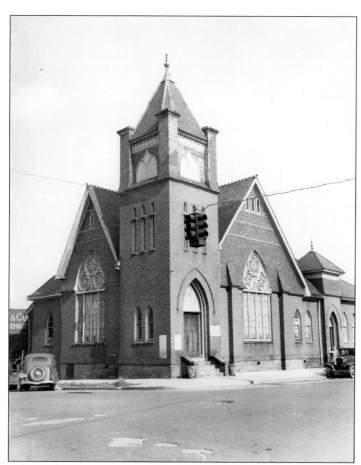

The Toccoa First United Methodist Church organized very early and met in several locations before this church building was completed in 1898, located on the corner of Doyle and Pond Streets. The present worship complex, on the corner of East Tugalo and Short Streets, was dedicated in 1957. (Courtesy of the Stephens County Historical Society.)

These women enjoy a moment of laughter after attending services at First Methodist Church in Toccoa. In the late 1800s and early 1900s, downtown streets were lined with houses, churches, and businesses. (Courtesy of the Stephens County Historical Society.)

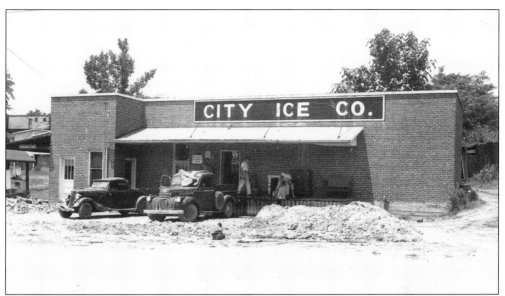

Toccoa had three ice companies, including City Ice. Residents could either pick up ice for their iceboxes or have it delivered. (Courtesy of the Stephens County Historical Society.)

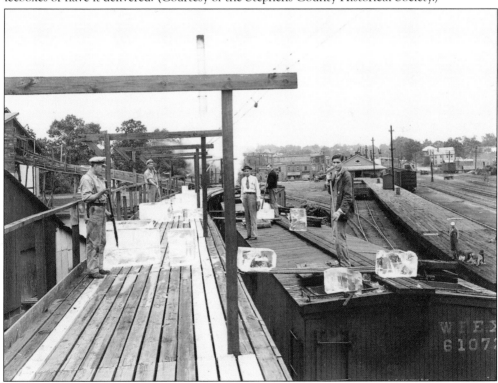

T.D. Honea, owner of the Colonial Ice Plant, works with his crew loading large blocks of ice into freight cars near the Toccoa Depot. Ice was made in Toccoa and distributed by rail to towns up and down the rail system. From left to right are Sam Bohannon, unidentified, Grady Honea, Ernest Stewart, and Clyde Honea. In the background are the Toccoa Depot and Henry Power Café on the corner. (Courtesy of the Stephens County Historical Society.)

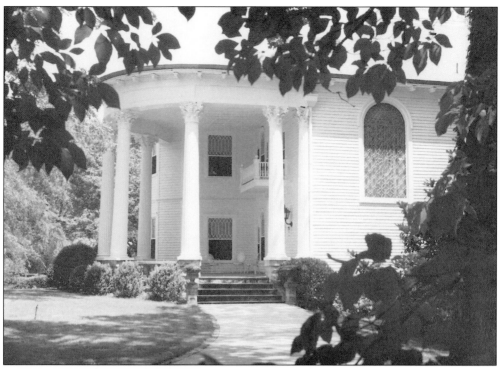

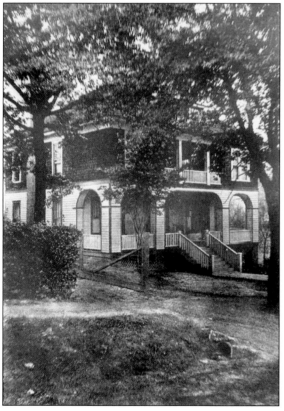

The Schaefer home was a true architectural gem in the city. For years, its gracious lawn, welcoming porch, and federal columns were a landmark for the community. In later years, it fell into disrepair and was taken down. Today, the grounds and the flora that once surrounded the house remain, and in the spring these still provide a gentle reminder of what gracious life was like in a southern town. (Courtesy of the Stephens County Historical Society.)

This house, located on Savannah Street, was built for George Daniel Trogdon in 1904. Since that time, it has seen extensive renovation. George Trogdon worked for the Toccoa Furniture Company until he began his own furniture company, Trogdon Furniture, in 1920. (Courtesy of the Stephens County Historical Society.)

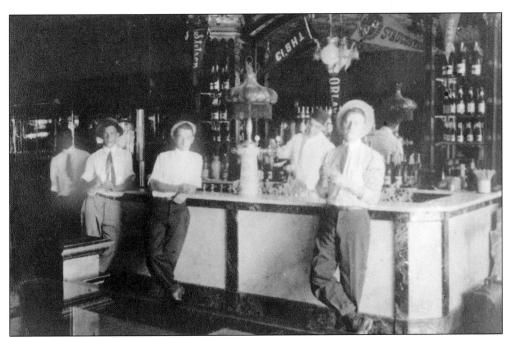

Standing from left to right in Kimsey's Drug Store are Nathaniel Lipscomb, Gibbs Carter, George Cooper, Dick Barron behind the fountain, and Fred Hayes. Notice the banner on the mirror behind the counter. It reads, "THS '13." Most likely, this is a banner for Toccoa High School from 1913. (Courtesy of Stephens County Historical Society.)

The name Acree was connected with several businesses in Toccoa—an early funeral home seen in this 1951 photograph and Acree Oil, which was a Sinclair dealership. (Courtesy of the Stephens County Historical Society.)

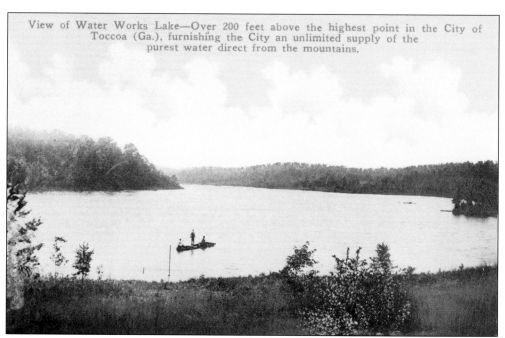

View of Water Works Lake—Over 200 feet above the highest point in the City of
Toccoa (Ga.), furnishing the City an unlimited supply of the
purest water direct from the mountains.

This postcard photograph of the waterworks lake reminds one that it is over 200 feet above the highest point in the city. Toccoa has a vast supply of water. In fact, the card reads, "an unlimited supply of the purest water direct from the mountains." (Courtesy of Kelly Vickers.)

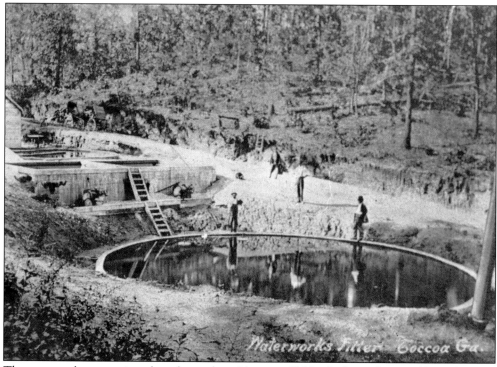

The waterworks processing plant, located on Alternate 17 North above the city, filters the city's water supply. (Courtesy of the Stephens County Historical Society.)

Construction was in full swing in the early 1900s, and local carpenters had plenty to do. Pictured here are, from left to right, Osborne Bohannan, England Yearwood, Lewis Scott, A.J. Scott, and Jim Scott. (Courtesy of the Toccoa Falls College Archives.)

As far as those who live in Toccoa remember, "There has always been a Gate Cottage" near the base of Toccoa Falls. In the early 1900s, it was a place where travelers could pause for a moment before continuing up the short pathway to the 186-foot-high waterfalls known as Toccoa. (Courtesy of the Toccoa Falls College Archives.)

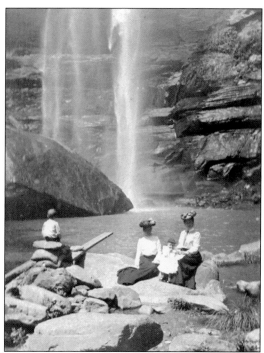

Visitors to the falls marveled at its impressive size and height. It was a tourist destination, and those who came usually found a way, even in the very early years, to record their memories with a photograph. (Courtesy of the Toccoa Falls College Archives.)

Glenn Falls, or Little Falls as it is more widely known, is located a half mile above Toccoa Falls. It was given the name by Evelyn Forrest, who grew up in Appleton, Massachusetts. A small creek near her girlhood home was called Glenn Creek, and it was only natural for her to name this recreational falls after a place she knew so well. Over the years, the falls has been a destination for picnics and wading in the cool stream just above the falls in summer. (Courtesy of the Toccoa Falls College Archives.)

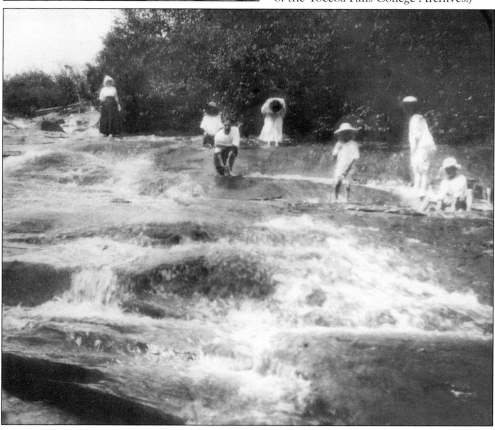

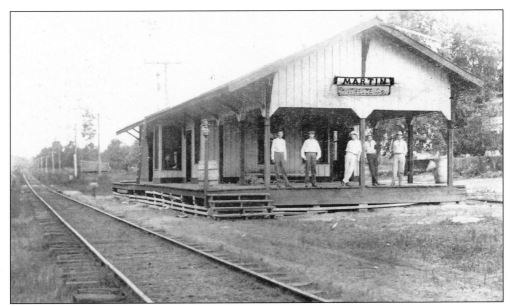

By 1877, the railroad was completed from Toccoa to Elberton. The Southern Express Depot at Martin was located where the Red Hollow Road crosses the Airline Railroad. Marketing of cotton to far away textile centers such as Atlanta, Charlotte, and Greenville thus became economically feasible. People brought their cotton from miles away to be ginned at the Martin Gin Company—sometimes up to 40 bales a day. On the porch, from left to right, are W.A. Mitchell, Clarence C. Rush, John E. Brown, Dave Landrum, and Tom Stovall. (Courtesy of the Stephens County Historical Society.)

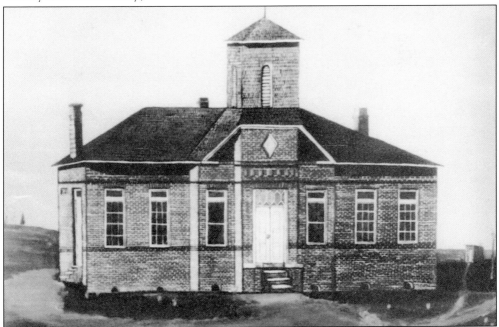

The Martin Institute was a brick building constructed in 1902 as a private school. It eventually closed during the Depression due to low enrollment. The building houses the Martin Community Center today. (Courtesy of the Stephens County Historical Society.)

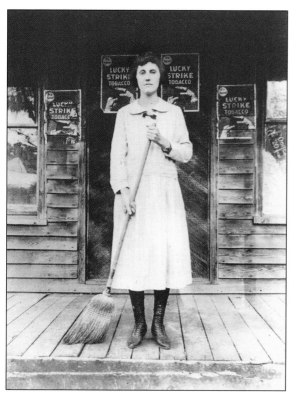

In these photographs, Adeline Elizabeth Coe tends the store owned by David Moseley in Eastanollee. She later became part owner of the store. (Courtesy of the Stephens County Historical Society.)

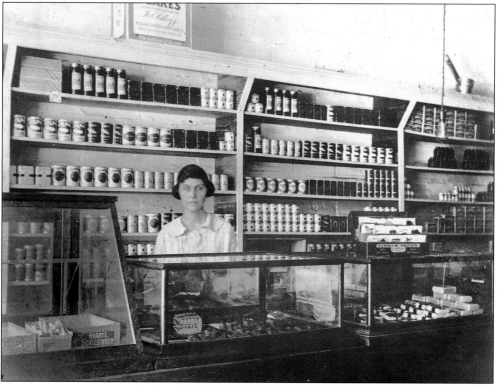

George Farmer of Mountain Grove community is pictured here on the front steps of his home with his children Sanford and Hansel. The Farmer daughters are standing in the doorway. Hansel later lost his life while serving as an aerial gunner at the very end of World War II. (Courtesy of Steve Tilley.)

George's father, William Crawford Farmer, is sitting in his favorite chair with his cane one fine afternoon. In his later years, his family built a small cabin for him behind the main house with a string hung between the houses and a bell attached. The bell was used by the family to call William Farmer when meals were ready. (Courtesy of Steve Tilley.)

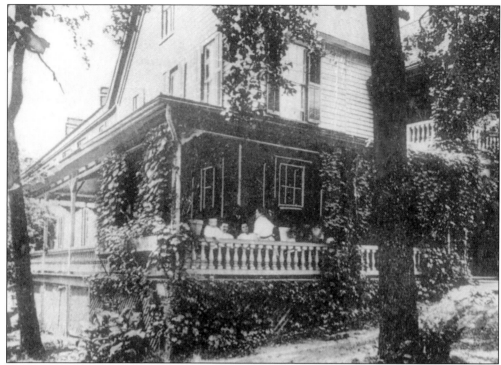

After fire destroyed the Edwards House Hotel, G.W. Edwards built a hotel on the corner of Alexander and Tugalo Streets. The hotel was later sold to John and Texanna Burgess, who named it the Albemarle after their former place of residence. The hotel was eventually purchased by its manager, Mrs. J.O. Freeman. When the hotel later burned, she rebuilt in brick. Hotel rates at the Albemarle were $2.25 per person, which included supper, room, and breakfast. (Courtesy of Kelly Vickers.)

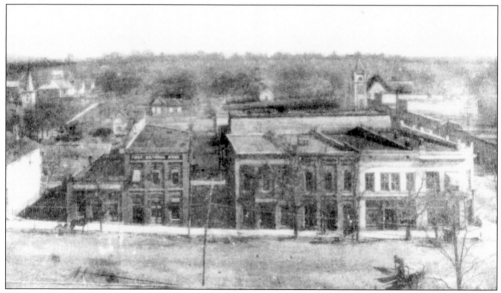

This c. 1906 bird's-eye view of Toccoa may have been taken from the top of the courthouse as it was being built. (Courtesy of the Stephens County Historical Society.)

# *Three*

# A New County Seat

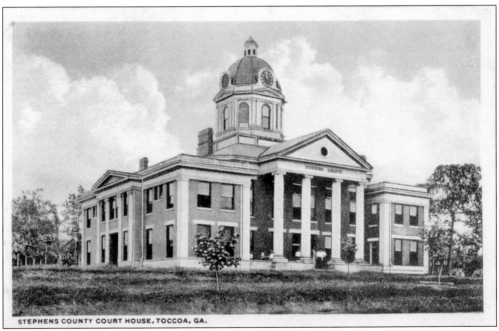

STEPHENS COUNTY COURT HOUSE, TOCCOA, GA.

In the early fall of 1905, the Georgia General Assembly approved the creation of the new Stephens County with Toccoa as the county seat. Stephens County was created from portions of both Franklin and Habersham Counties. It was reported in the *Atlanta Constitution* that upwards of 7,000 people attended the celebratory event. This is a very early photograph of the new Stephens County Courthouse, built in 1907. (Courtesy of Kelly Vickers.)

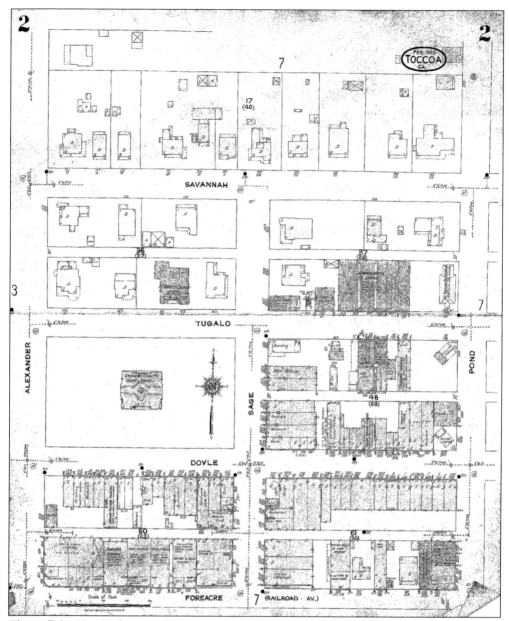

This is Folio No. 2 of a recently discovered city survey showing the detailed location of many buildings and structures in the year 1923. The complete set is on file with the Stephens County Historical Society. (Courtesy of the Stephens County Historical Society.)

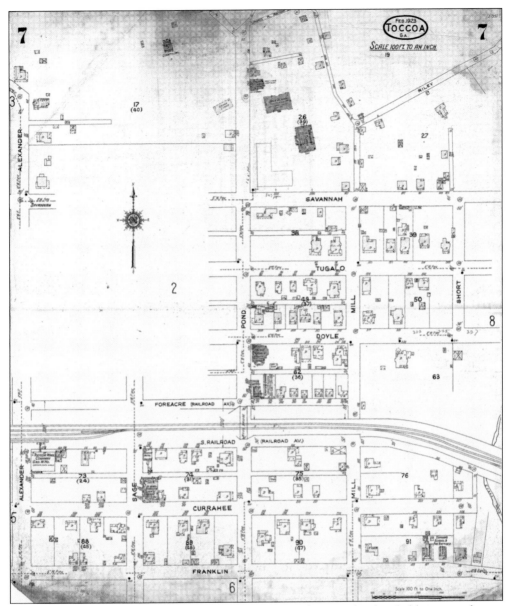

This is Folio No. 7 of a recently discovered city survey showing the detailed location of many buildings and structures in the year 1923. The complete set is on file with the Stephens County Historical Society. (Courtesy of the Stephens County Historical Society.)

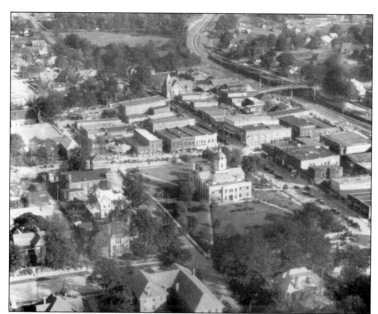

This is a 1930s aerial photograph of downtown Toccoa. Notice the Methodist, Presbyterian, and Baptist churches, the service stations, and the Star Theatre. (Courtesy of the Stephens County Historical Society.)

This 1905 photograph records the first Stephens County leaders, following the very first election. They are, from left to right, (first row) William Bailey, clerk; Ben Brown, ordinary; and Bud Mize, tax collector; (second row) W.A. Stowe, sheriff; Fermer Barrett, representative; McAllister Jarrett, tax receiver; and Charles Dance, treasurer. (Courtesy of the Stephens County Historical Society.)

Dr. Arthur Thomas Cline became pastor of the First Baptist Church of Toccoa in 1927 and served the congregation through 1956. Under his ministry, the church saw tremendous growth. He enjoyed a mutual admiration and respect with area pastors, community leaders, and citizens. He is pictured with his wife, Sara Ruth. (Courtesy of Toccoa Falls College Archives.)

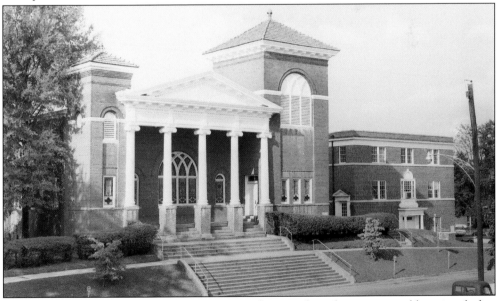

The First Baptist Church of Toccoa was organized very early and met in several locations before the building here, across from the courthouse, was completed in 1906. In 1965, the "Church on the Square" moved to its current location on Tugalo Street and Prather Bridge Road. (Courtesy of the Stephens County Historical Society.)

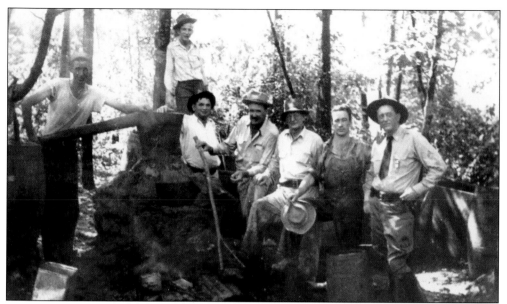

One local Toccoa resident recalled the early days of making moonshine: "For us, it was a way of life. I can remember one night during dinner the sheriff came in our front door to arrest my father for making 'shine,' but he jumped through a window in the back of the house and got away. Daddy was never caught." Pictured here in 1945, Sheriff Henry Moseley has broken up a bootlegging operation discovered in somebody's backyard. (Courtesy of the Stephens County Historical Society.)

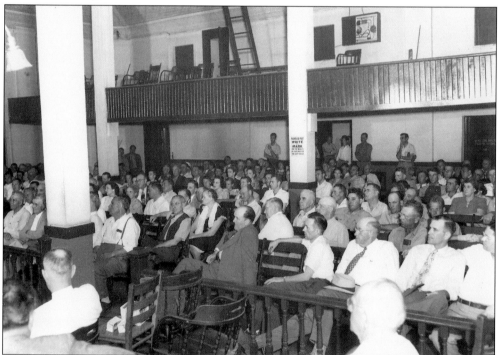

This must have been an interesting trial because the courthouse was filled to capacity when this photograph was taken in 1950. (Courtesy of the Stephens County Historical Society.)

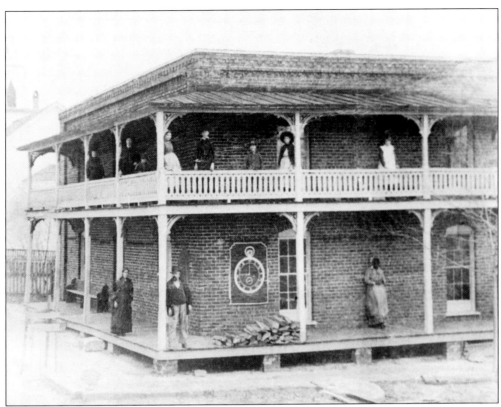

The McCrosky Boarding House stood on the corner of Fouracre and Pond Streets, next to the overhead bridge. Over the years, a number of local Toccoa families operated boardinghouses in this building. Before it was demolished in the late 1940s, it was an apartment building. (Courtesy of the Stephens County Historical Society.)

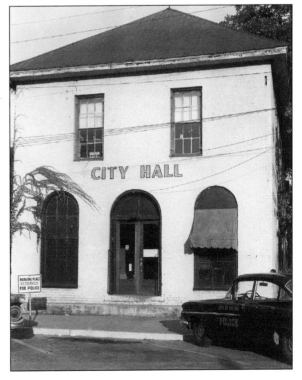

City hall was a hub of planning and civic activity in the early 1900s. The city library was also located upstairs for some years. In the 1950s, city hall bore a newly painted white exterior and was still located on the corner of Sage and Tugalo Streets. Eventually, it was relocated to the old post office building on the corner of Alexander and Doyle Streets. (Courtesy of the Stephens County Historical Society.)

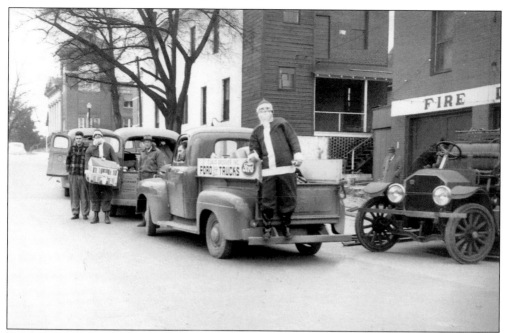

Ready for Christmas and decked out in Santa outfits, Toccoa citizens are always quick to collect gifts for those in need. The back of city hall can be seen to the right in this photograph. The original First Baptist Church is also in the background, and the Toccoa Fire Department is in the foreground. (Courtesy of the Stephens County Historical Society.)

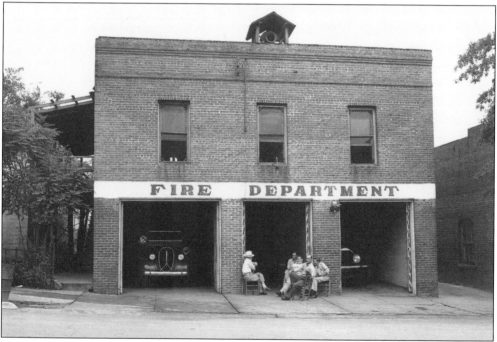

Toccoa residents have always been proud of their fire department. They were first responders to the many fires that plagued small town communities in the early 1900s. Notice the siren on the top of this brick structure. (Courtesy of the Stephens County Historical Society.)

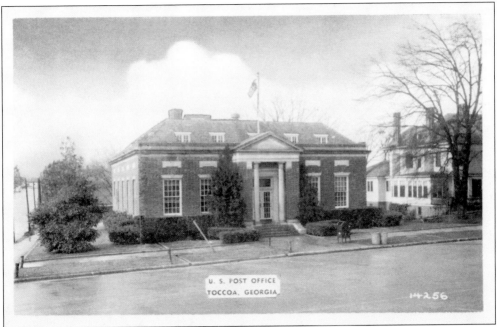

When this building was constructed, it housed the post office, and it remained that way for years. Today, it is home to city hall. (Courtesy of the Stephens County Historical Society.)

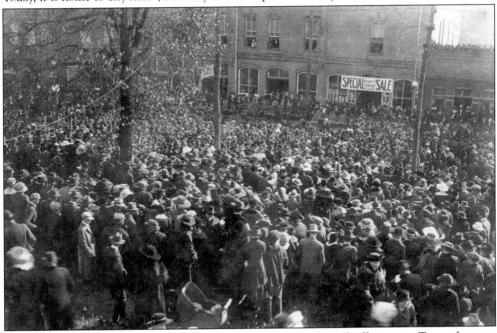

According to the *Toccoa Record*, "The largest crowd (7,000 to 10,000) of humanity Toccoa has ever entertained greeted Billy Sunday when he arrived in Toccoa. He was accompanied by his 'family' of church workers, including Homer Rodeheaver with his trombone; the American Quartet from Camp Gordon, and several well-known citizens and ministers from Atlanta. Rev. R.A. Forrest of Toccoa Falls Institute, was instrumental in getting the great evangelist to Toccoa." (Courtesy of the Toccoa Falls College Archives.)

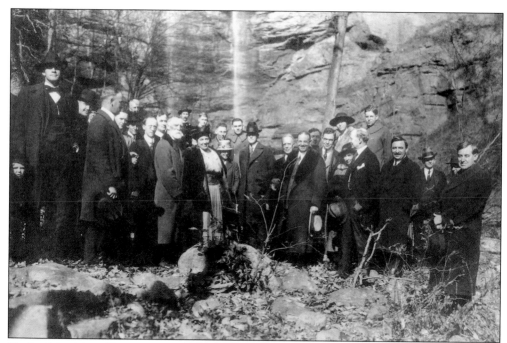

During his visit to Toccoa, evangelist Billy Sunday, in the center with glasses and hat in hand, visited Toccoa Falls. Dr. R.A. Forrest, founder of Toccoa Falls College, is fourth from the right. (Courtesy of the Toccoa Falls College Archives.)

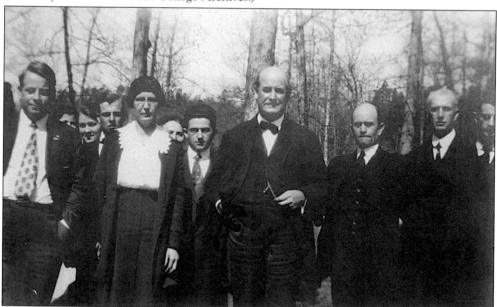

An article in the *Toccoa Record* states, "William Jennings Bryan, "The Great Commoner" came to Toccoa . . . Local pastors were notified and the First Baptist church was accepted for the noted layman. Every Toccoan became a walking telephone and the news was soon circulated . . . Long before 8:00 p.m. the church seats were filled and chairs were brought from other rooms. The Rev. John Ellis of the First Methodist church said the invocation." (Courtesy of the Toccoa Falls College Archives.)

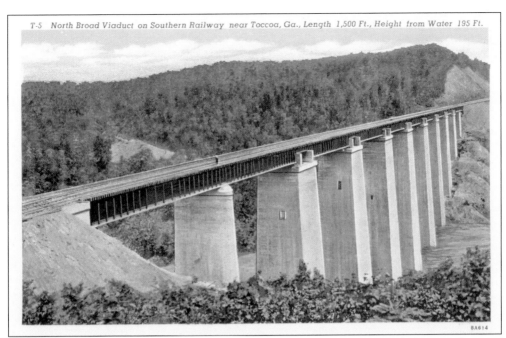

The Southern Railway's 1873 southern approach to Toccoa was rerouted with the completion of the Wells Viaduct (named after its chief engineer, W.H. Wells) in 1919. It is also referred to as the North Broad Viaduct. The trestle spans 1,500 feet and is over 200 feet above the North Fork of the Broad River beneath. (Courtesy of Kelly Vickers.)

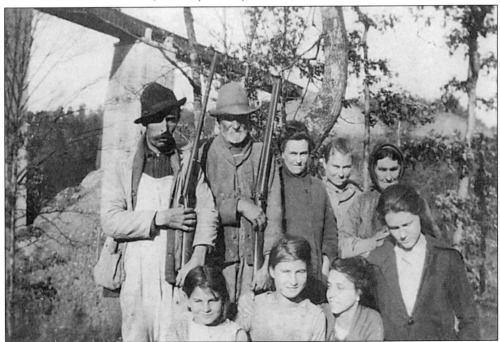

The family in this photograph lived in the vicinity of the North Broad Viaduct. Here, they pose with a group of students from Toccoa Falls Institute who had hiked to the area for a visit. (Courtesy of the Toccoa Falls College Archives.)

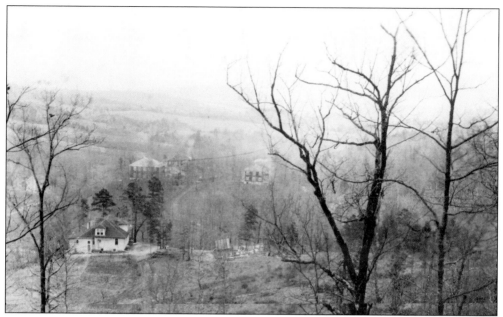

Here is a photograph of early Toccoa and Stephens County north of the city near Toccoa Falls. Much of the land remains cut back and ready to be farmed. (Courtesy of the Toccoa Falls College Archives.)

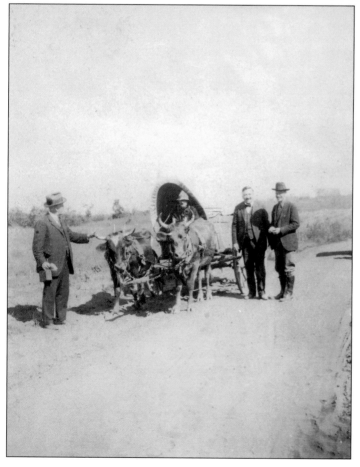

While it is hard to imagine, covered wagons were still used for travel in Toccoa in the early 1900s. Richard Forrest, founder of Toccoa Falls Institute, is pictured here with others who were on their way into the city around 1912. (Courtesy of the Toccoa Falls College Archives.)

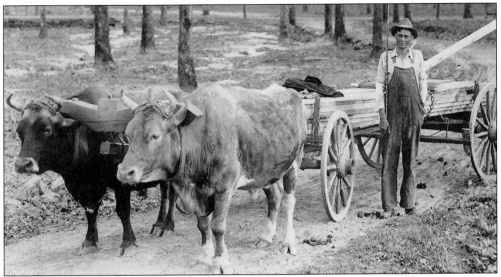

Tom Scott is delivering a load of wood to the Toccoa Falls Institute campus. Dr. R.A. Forrest purchased the oxen for $100 from Arch Wilbanks. Wilbanks's daughter Martha delivered the oxen to Forrest, but would not leave the yoke with him until he paid her an additional $1 for it. (Courtesy of the Toccoa Falls College Archives.)

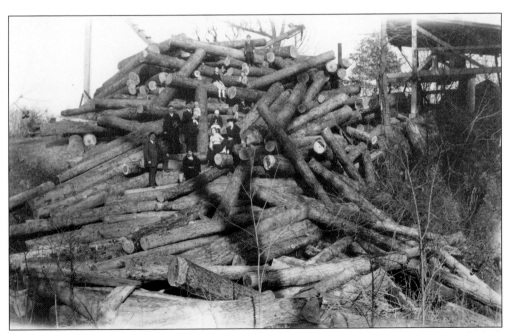

One of the earliest sawmills was started in 1884 by Henry Fed Rider in the Lakeview and Black Mountain area. Because of the abundance of hardwood, many of the buildings and houses in the Toccoa area were constructed of locally milled lumber. Here, freshly cut timber is readied for the mill at Toccoa Falls in 1917. (Courtesy of the Toccoa Falls College Archives.)

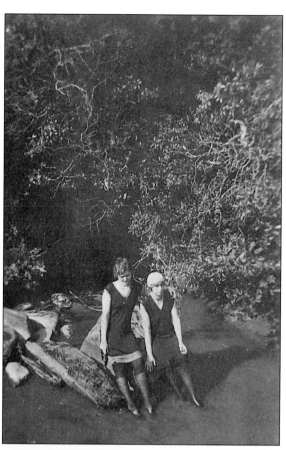

Here, girls enjoy a refreshing wade in the cool waters of Toccoa Creek, always a popular pastime. (Courtesy of the Toccoa Falls College Archives.)

Students at Toccoa Falls Institute are ready for a dive into the pond. (Courtesy of the Toccoa Falls College Archives.)

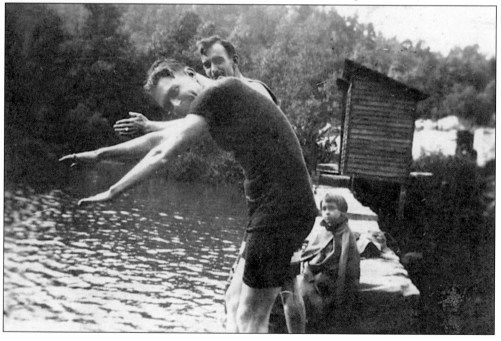

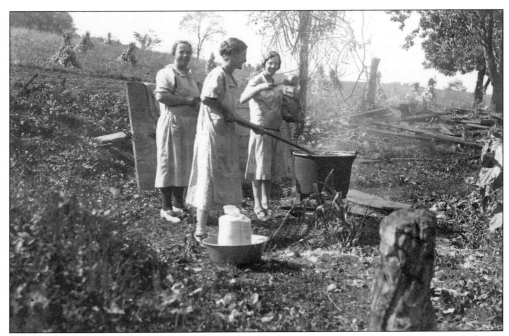

Apple butter was made every year in the early fall when the fruit was ripe and at its peak flavor. It was an all-day event, beginning early in the morning. Fires were made under large kettles, and apples were pared and placed in the boiling water, along with spices and sugar. Lots of butter was used to coat the inside rim of the kettle. The mixture was stirred with large wooden paddles until it thickened, then later that evening, poured into glass jars and sealed. (Courtesy of the Toccoa Falls College Archives.)

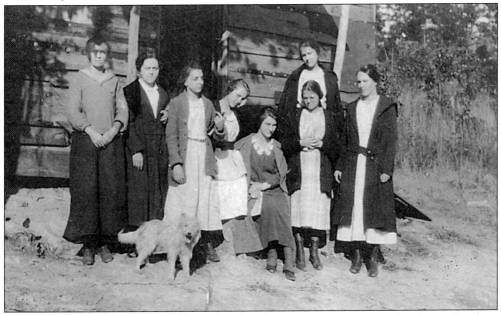

When it was not feasible for people who lived far from town to come in to the city on Sundays, often Sunday school teachers would visit them, especially in rural areas. Here, Mollie Hill gathers with her class for a quick photograph. (Courtesy of the Toccoa Falls College Archives.)

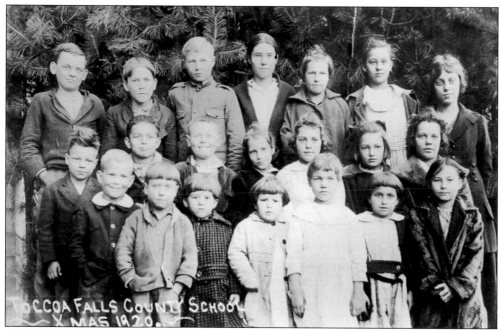

In 1914, Evelyn Forrest saw a need for spiritual and normal classroom training among the children who lived near Toccoa Falls. She started Toccoa Falls Grammar School in an old shack on the campus of Toccoa Falls Institute. There was no insulation, but there was a large wood-burning stove that was used to heat the building in the winter. Years later, the Stephens County School Board assumed responsibility for the school. Here the children are pictured with their teacher Alice Larson Barnes at Christmas in 1920. (Courtesy of the Toccoa Falls College Archives.)

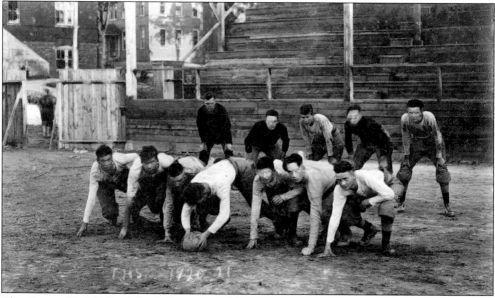

The Toccoa High School football team in 1920–1921 was coached by Earl Adams. From left to right are (first row) Witham Brown, Bevo Lloyd, Oren Chatham, Odelle Andrews, Ralph Couch, Red Foiter, and Abel Lee McConnell; (second row) Melvin Chumley, Stonewall Bennett, Ligon Rodgers, and Rufus Harding. (Courtesy of the Stephens County Historical Society.)

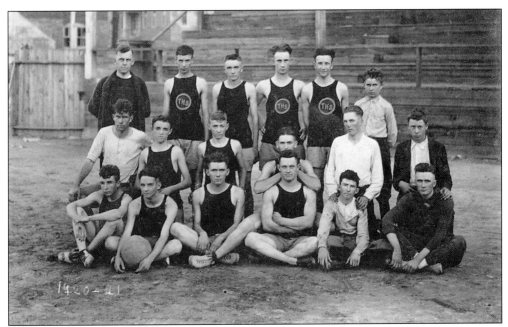

The Toccoa High School basketball team in 1920–1921 was coached by F.C. Chandler. From left to right are (first row) Jim Toney, Alfred Simpson, Lloyd Poole, Stonewall Bennett, Lent Stephens, and Robbie Poole; (second row) Floyd Stephens, Albert Fowler, Bill Mize, Winfield Snelson, Mel Adams, and Sweden Stephens; (third row) Withan Brown, Abel Lee McConnell, Odelle Andrews, Riley Mitchell, and Reid Davis. (Courtesy of the Stephens County Historical Society.)

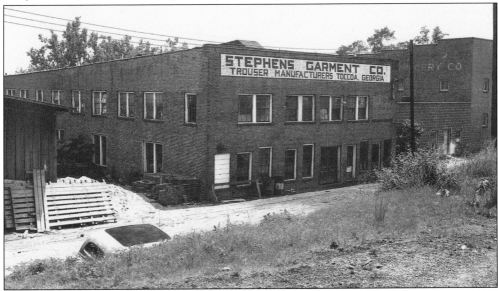

Industrialized Toccoa was a hub of commercial activity. Stephens Garment Factory is proof that the rail lines shipped locally made goods across the country. Citizens held local jobs and were proud of the goods they made each day. Stephens Garment Factory opened in 1939 to manufacture trousers for men and boys. In 1950, the name was changed to Wright Manufacturing. Millions of pairs of trousers were made for both government and civilian purchase. (Courtesy of the Stephens County Historical Society.)

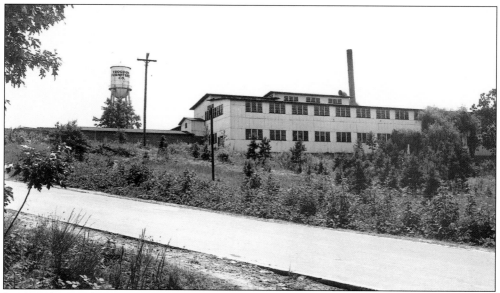

In 1920, the Trogdon Furniture Company factory was built by George D. Trogdon and remained in business for over 60 years. The factory was located on Elberton Street and manufactured primarily dining room furniture. (Courtesy of the Stephens County Historical Society.)

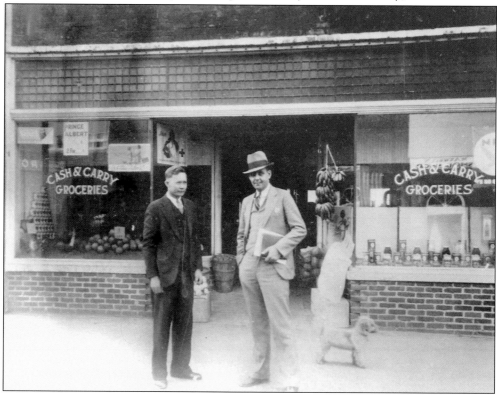

Dewey DeFoor, owner of the Cash and Carry grocery on Doyle Street, and Ray McCay, salesman for the Carter Wholesale Grocery Company, pose for this photograph sometime in the 1930s. (Courtesy of the Stephens County Historical Society.)

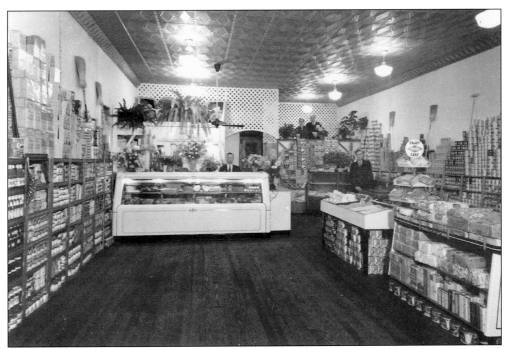

Terrell Grocery Store was located on Doyle Street. Fred and Ruth Terrell were the owners. Pictured in 1938 are Mr. Harris, the butcher (left) and Mr. Edwards, the clerk. (Courtesy of the Stephens County Historical Society.)

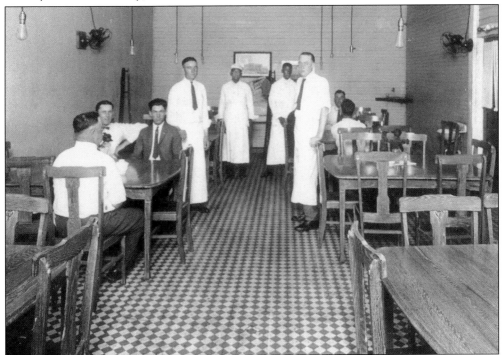

Terrell's Café was established by Fred and Ruth Terrell in 1941 as one of their many business ventures. (Courtesy of the Stephens County Historical Society.)

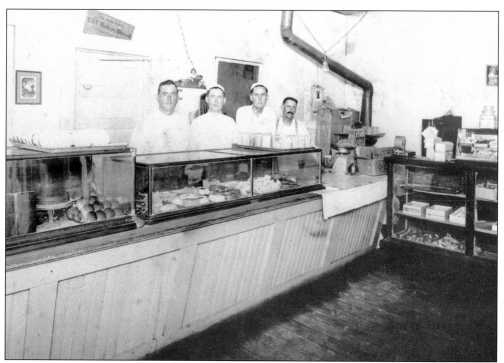

In these photographs of the Toccoa Bakery, the employees are, from left to right, T.H. Taylor, Cevere Taylor, Guy Taylor, and Will Hicks. (Courtesy of the Stephens County Historical Society.)

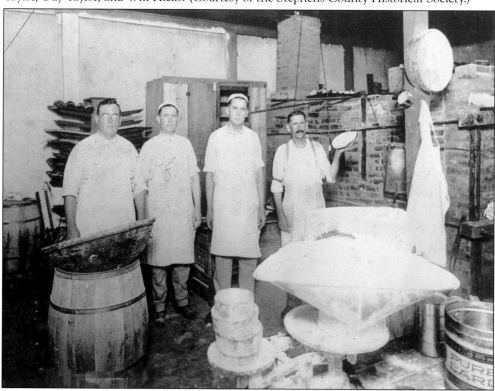

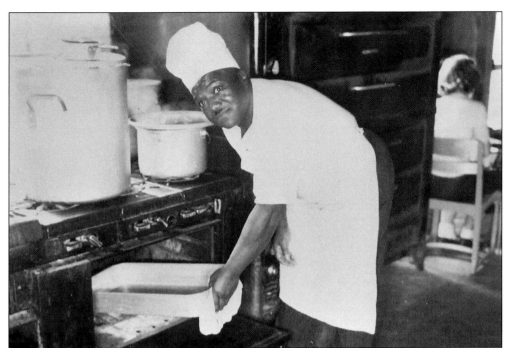

Will Prather, in his chef's hat, is cooking at Toccoa Falls Institute. (Courtesy of the Toccoa Falls College Archives.)

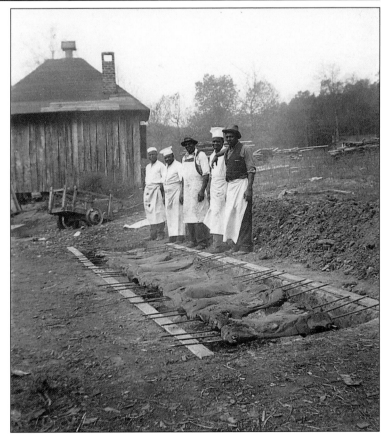

Hogs were butchered every fall. The meat was smoked, cured, and stored for the long winter months. (Courtesy of the Toccoa Falls College Archives.)

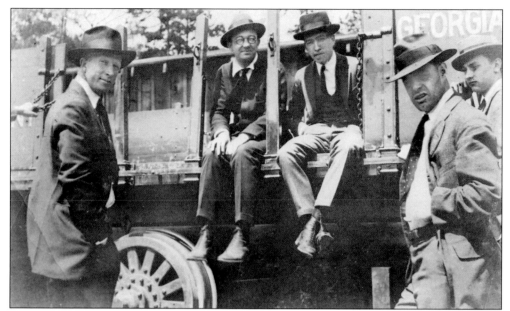

The Dinky Line Railroad was built in 1924 to transport materials (and workers) from the Tugalo Station to Yonah Dam, where construction was underway for the Georgia Power dam. On the far left is Robert Edward Anderson, father of Paul Anderson. (Photograph given by Paula Anderson Schaefer to the Stephens County Historical Society; courtesy of the Stephens County Historical Society.)

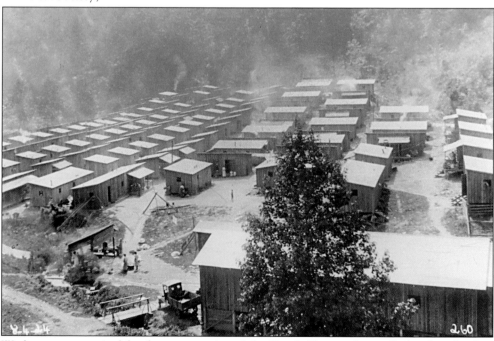

Workers were recruited for the construction of the Yonah Dam and actually lived at the dam site for the duration of the project. Here the so-called "Negro Camp" consisted of 93 one room, 42 two room, and 3 three-room living quarters, as well as one dance hall. (Courtesy of Georgia Power, Yonah Dam Project.)

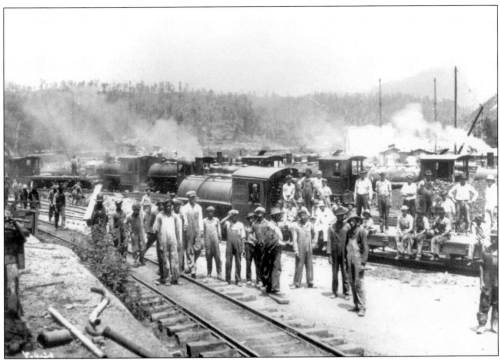

Workers gather to meet the Dinky Line crews for another day's work on Yonah Dam. (Courtesy of Georgia Power, Yonah Dam Project.)

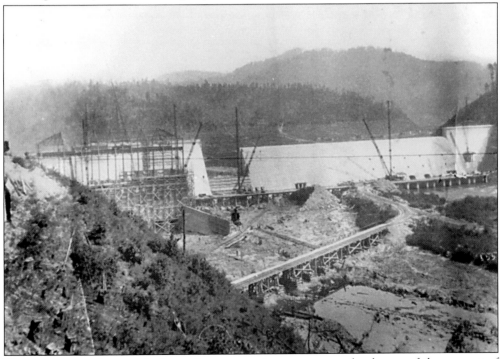

This interesting photograph shows the construction progress on the dam as of the summer of 1925. (Courtesy of Georgia Power, Yonah Dam Project.)

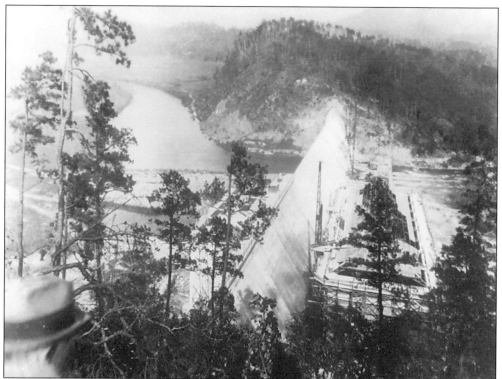

Yonah Dam, pictured here nearing completion in the fall of 1925, would form the 320-acre Lake Yonah. This photograph shows the river behind the dam before flooding. When full, the lake is 70 feet deep at the dam. (Courtesy of Georgia Power, Yonah Dam Project.)

The First Presbyterian Church of Toccoa is seen here soon after its relocation across the street to Tugalo and Pond Streets in 1926. Dr. Richard Forrest, president of Toccoa Falls Institute, was called as pastor in 1925 and served in this capacity for 25 years. (Courtesy of the Stephens County Historical Society.)

This photograph of Richard and Evelyn Forrest was taken at the dedication of R.G. LeTourneau's new radio station, WLET-FM, in 1947. Dignitaries attending the event included Georgia governor Melvin Thompson and Sen. Richard Russell. (Photograph taken by Virgle E. Craig and donated by the Craig family to the Stephens County Historical Society; courtesy of the Stephens County Historical Society.)

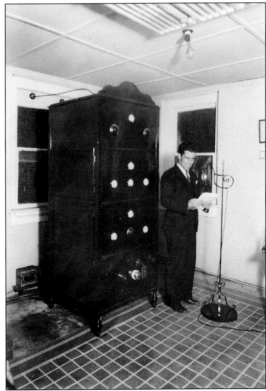

In 1927, Toccoa's first radio station WTFI (for Toccoa Falls Institute) broadcast from the basement of the First Presbyterian Church. It was the second radio station in north Georgia and was rated the second most popular in Georgia. This photograph shows Kelly Barnes, WTFI's operator and announcer, standing in front of an early transmitter. The station was sold in 1931 and moved to Athens, and later, Atlanta, with new call letters. (Courtesy of the Toccoa Falls College Archives.)

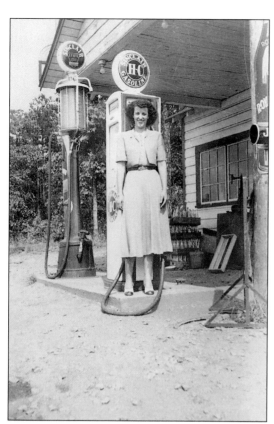

It is believed that this Sinclair Service Station was located on West Currahee Street. (Courtesy of the Norris family.)

J.C. Collins' Willard Pan Am Service Station was popular in the 1920s. Fred Northcutt is seen on the driver side of the car. In the 1950s, the brand was replaced by Amoco, incorporating the famous red, white, and blue along with a torch. (Courtesy of the Stephens County Historical Society.)

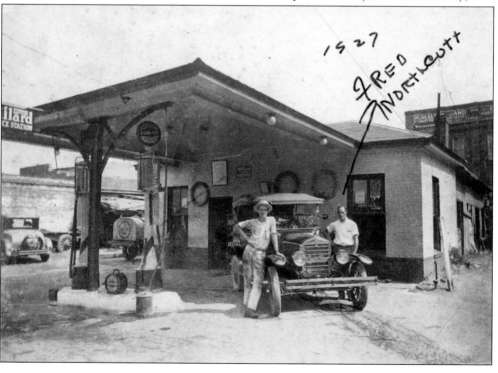

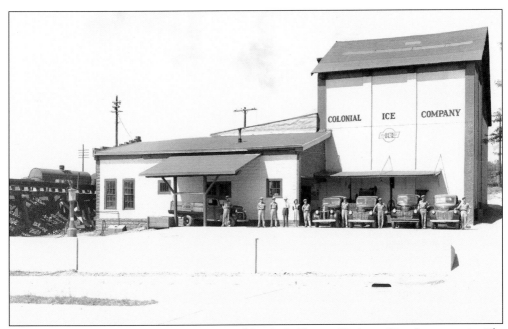

Colonial Ice and Coal Company was owned by C.G. Honea. Kathryn Trogdon notes in *The History of Stephens County, Georgia*, "A familiar sight in the summer was the ice wagon, which delivered ice to each house." Most Toccoa housewives had ice cards, which indicated the number of pounds of ice they needed. Children followed the ice wagons as they rolled through the city, eating pieces of chipped ice. (Courtesy of the Stephens County Historical Society.)

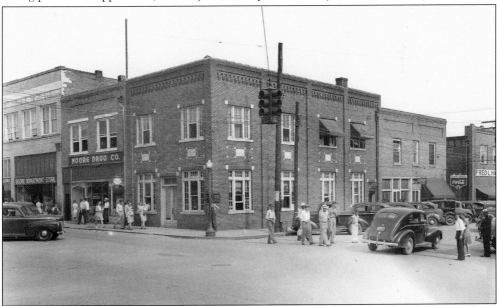

General stores began carrying patent medicines, but soon, the need came for additional services. Drugstores also became a place where lunch was served, ice cream floats were served, the latest news was exchanged, and young people met for dates. In this photograph, the Moore Drug Company was located near the corner of Doyle and Sage Streets and was run by Doyle M. Moore. (Courtesy of the Stephens County Historical Society.)

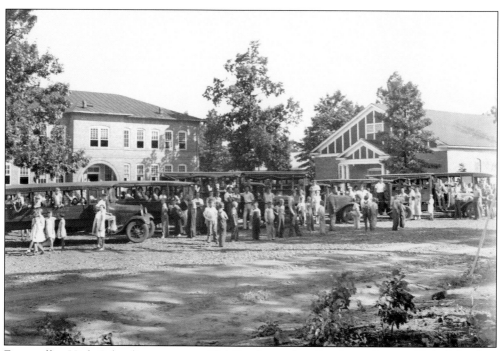

Eastanollee High School's name was officially changed to Stephens County High School in 1929. However, the new name was not used on the diplomas until 1936. The school buses in this photograph were introduced in 1926. (Courtesy of the Stephens County Historical Society.)

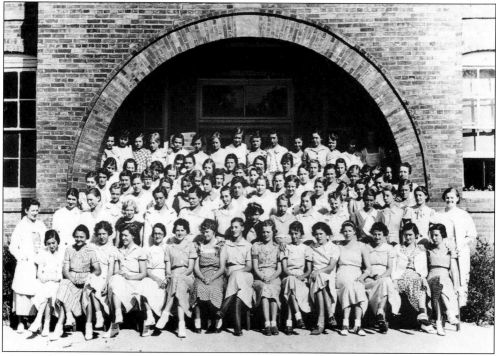

The Stephens County High School (previously Eastanollee High School) girl's home economics class appears here in 1932. (Courtesy of the Stephens County Historical Society.)

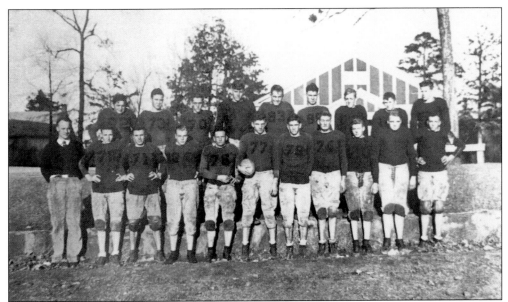

The 1938–1939 Stephens County High School football team at Eastanollee School included, from left to right, (first row) Coach Oscar Adams, Joe Frank Stowe, George Thompson, Ray McAlister, Jack Holcomb, Emory Brown, Dorsey Davis (1), Ried Farmer, Ralph McAlister, Jesse Alexander, and Clyde Loden; (second row) Joel Holcomb, Robert Perkins, LeRoy Pulliam, James Ayers, J.D. Caudell, Jr. Davis, Dorsey Davis (2), Herbert Hosea, and Jeff Davis. (Courtesy of the Stephens County Historical Society.)

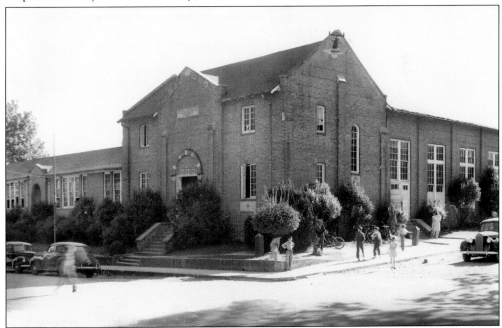

The Toccoa High School was built in 1923 on the corner of North Pond and Savannah Streets. In 1967, Whitman Street High School merged with Toccoa High. Toccoa High School continued to serve the youth of the city until consolidation in 1972, with Stephens County High School at the new White Pine Road location. (Courtesy of the Stephens County Historical Society.)

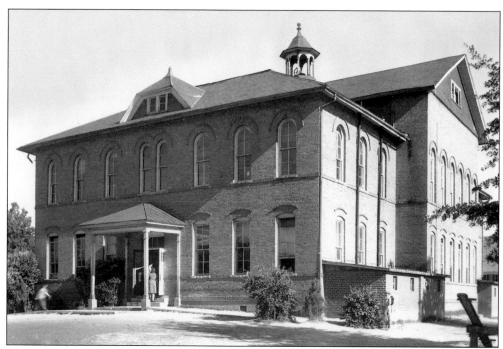

The Toccoa Grammar School was built in the 1890s on the North Pond and Savannah Streets lot, with the junior high building soon to follow. (Courtesy of the Stephens County Historical Society.)

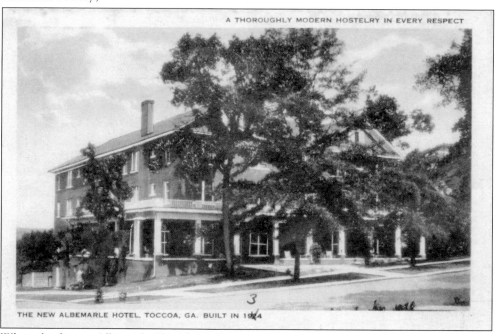

When the former Albemarle Hotel burned, it was replaced with a new brick building in 1934 by Mrs. J.O. Freeman, on the same location at the corner of Tugalo and Alexander Streets. The Albemarle continued to serve the finer hotel needs of the community until it was sold and converted into apartments. (Courtesy of Kelly Vickers.)

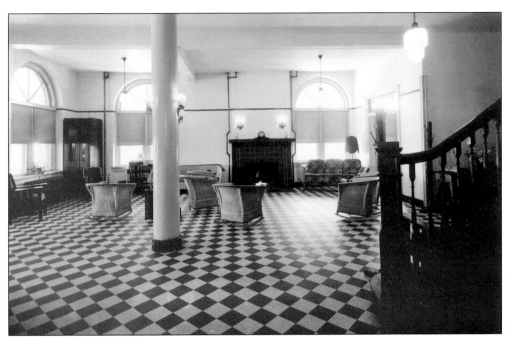

The lobby (above) and the dining room (below) of the new Albemarle were designed to serve and please guests. Note the old public telephone booth to the left in the lobby, and the fine chandeliers, columns, draperies, and wallpaper in the dining room. (Courtesy of the Stephens County Historical Society.)

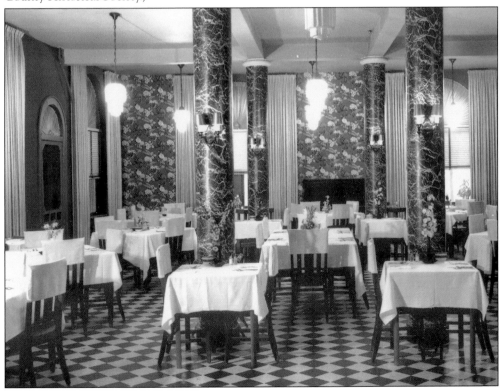

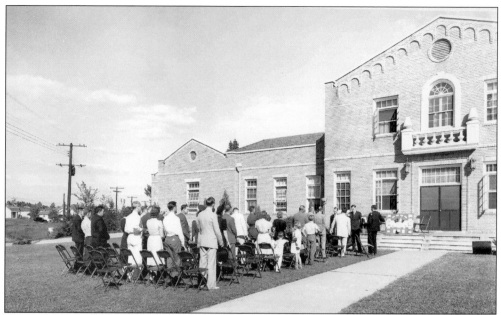

The Stephens County Hospital opened its doors in 1937 on the corner of North Boulevard and East Tugalo Street. In this photograph, soon after the hospital's opening, the front yard was used for the opening of a Gideon's International group in Toccoa. (Courtesy of the Virgle Craig family and the Stephens County Historical Society.)

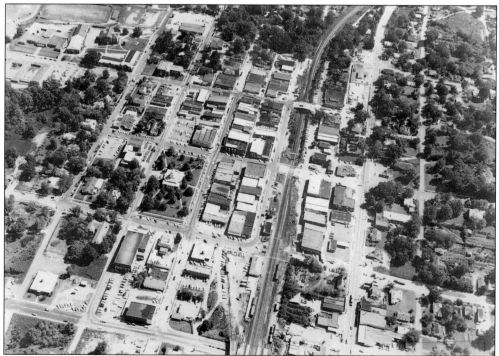

This aerial photograph of the downtown area shows the layout of the city school-system facilities as well as many other Toccoa landmarks that are now absent. (Courtesy of the Stephens County Historical Society.)

# *Four*

# THE WAR YEARS

At the invitation of Dr. R.A. Forrest of Toccoa Falls Institute, Christian businessman R.G. LeTourneau made the decision to open his earthmoving manufacturing plant here in Toccoa in 1938, bringing countless jobs and an infusion of capital into the county. The effect of his contribution to the economy of Toccoa and Stephens County cannot be understated, as he brought a whole new level of industry to this area. Many of the local industry leaders now in Toccoa were first employed by LeTourneau and later created companies of their own in the years following World War II. In this photograph, Miller Stovall (left) and Mack Whitehead appear to have just test-driven one of the many Tournapull earthmover models produced at the Toccoa plant. (Courtesy of the Virgle Craig family and the Stephens County Historical Society.)

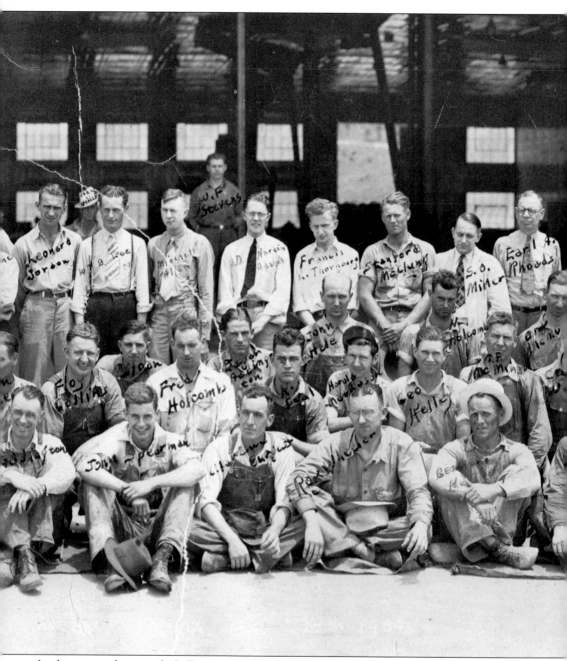

In this group photograph, LeTourneau is fourth from the right, standing, taking his hat off to his employees. The LeTourneau Empire of some 5,500 acres east of Toccoa consisted of seven enterprises: the LeTourneau Company of Georgia, Toccoa Falls Flying School Inc., Lake Louise

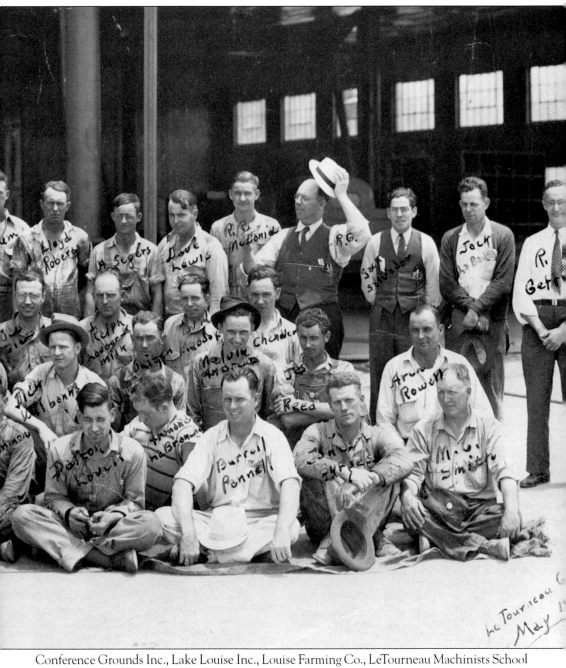

Conference Grounds Inc., Lake Louise Inc., Louise Farming Co., LeTourneau Machinists School Inc., and the Tournapull Housing Corporation. The township he created for his employees became known as Tournapull. (Courtesy of the Stephens County Historical Society.)

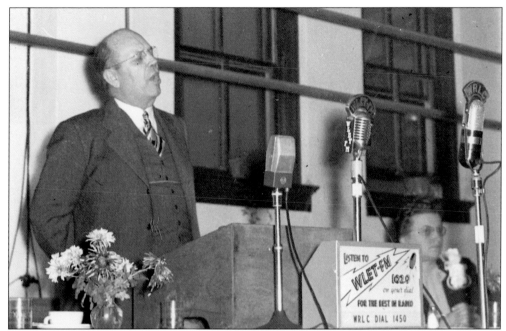

R.G. LeTourneau speaks at the dedication of his new radio station, WLET-FM. This event took place in 1947 in LeTourneau Hall on the campus of Toccoa Falls Institute and was attended by many state dignitaries. (Courtesy of the Virgle Craig family and the Stephens County Historical Society.)

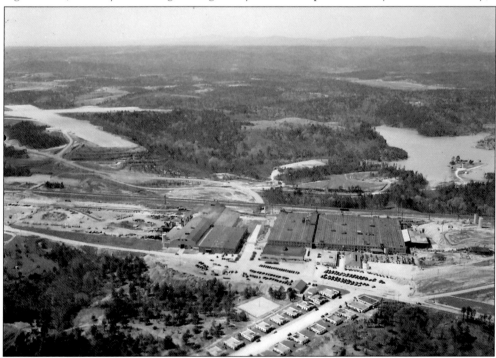

This aerial photograph only begins to communicate the dimensions of LeTourneau's development. Note the airport, Lake Louise, Tournapull community, and the central manufacturing plant. (Courtesy of the Stephens County Historical Society.)

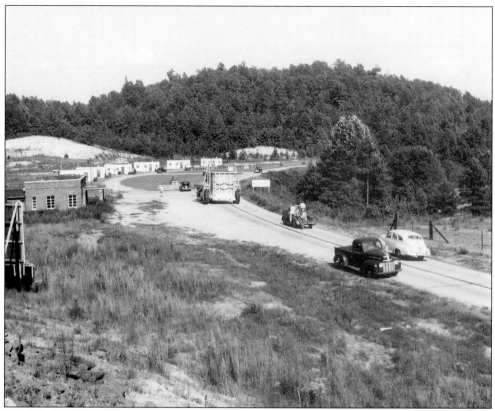

The Lake Louise Motel was constructed almost entirely of steel panels manufactured in the plant. The occasion for this photograph was the delivery of the first LeTourneau Baby Tournalayer house to the Lake Louise Motel location. It was designed to fill the need for fast, affordable housing. The Baby Tournalayer "layed" two or three concrete units, adding to the steel units. (Courtesy of Dale Hardy, Archivist for the R.G. LeTourneau Heritage Center.)

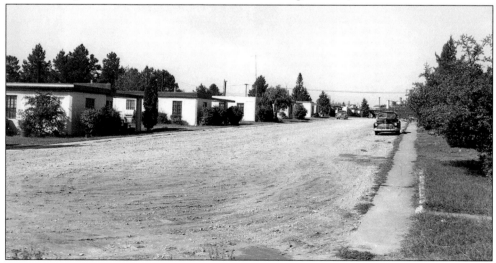

This is the main drive through LeTourneau Court, part of the Tournapull community. (Courtesy of Dale Hardy, archivist for the R.G. LeTourneau Heritage Center.)

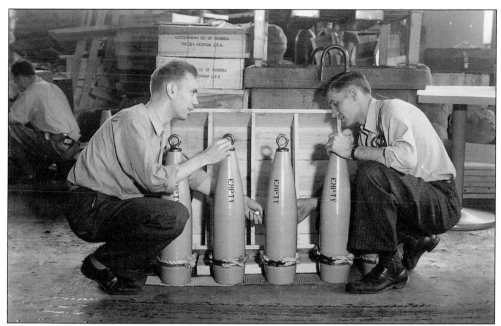

Two LeTourneau plant employees load the 155-millimeter shells made at the Toccoa plant. When needed, the plant could produce up to 90,000 of these shells per month. (Courtesy of the Stephens County Historical Society.)

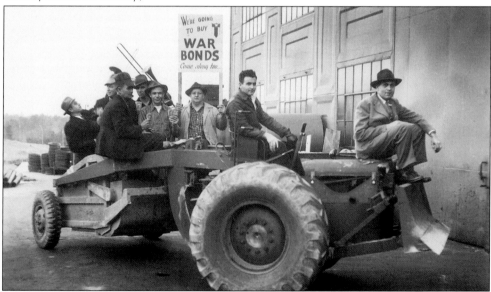

According to the Company Newsletter *NOW* from December 8, 1944, LeTourneau's contribution to the war effort was immense. The model D4 Tournapull shown here with a model Q Carryall was built specifically for the Army's Airborne Aviation Engineers. This photograph not only shows a unique Toccoa machine, but also the workers' patriotic spirit in encouraging others to buy war bonds. From this three-day campaign at Tournapull, $97,360 was raised in bond sales. Horace Thronburg, Tom Boggs, and Larry Kendricks were the tooters. Jimmy Reed drove the wagon, with Claude Rex holding down the radiator. (Courtesy of Dale Hardy, archivist for the R.G. LeTourneau Heritage Center.)

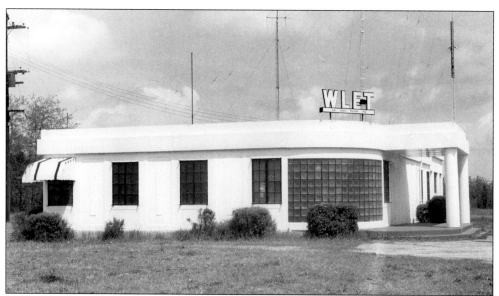

In 1947, LeTourneau founded WLET, located on Prather Bridge Road. LeTourneau later sold WLET to Virgle and Virginia Craig, who owned and operated it for many years. (Courtesy of the Stephens County Historical Society.)

A WLET staff worker makes a needed adjustment to the radio equipment. (Courtesy of the Stephens County Historical Society.)

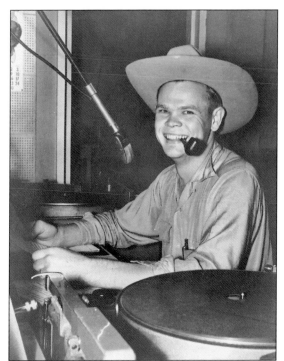

C.H. Sutton works the control board at WLET. He was a well-known radio personality, on the air for many years. (Courtesy of the Virgle Craig family and the Stephens County Historical Society.)

LeTourneau's unique Lake Louise Conference Center was named after his daughter Louise. During the war, LeTourneau made portions of the conference center, the two-story building between the spokes near the top right, available as a military hospital. The conference center was eventually sold to the Georgia Baptist Convention. (Courtesy of the Stephens County Historical Society.)

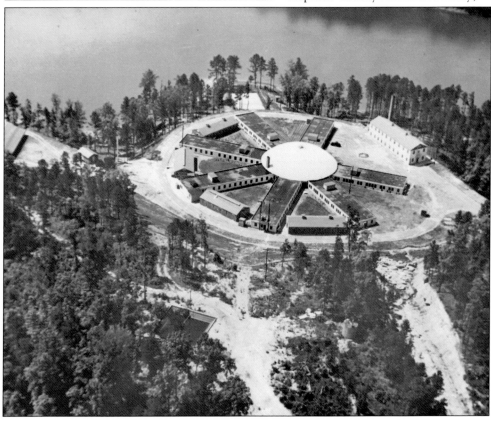

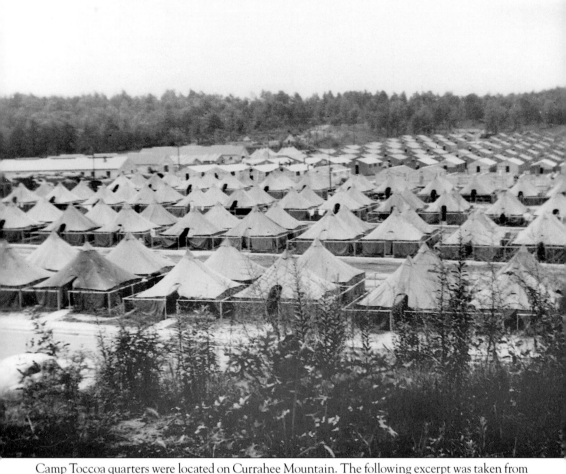

Camp Toccoa quarters were located on Currahee Mountain. The following excerpt was taken from the *Regiment Yearbook* following the war: "The 506th Parachute Infantry was activated on 20 July 1942. Prior to this date a small cadre of officers and non-commissioned officers were quartered in a wall tent area which had been euphoniously named 'Camp Toombs.' On the shoulders of these officers and men rested the responsibility of forming and training the great regiment which was later to make the camp's new name a famous one—'Toccoa.' Toccoa was the heat of the Georgia summer and fifty tortuous minutes three days a week, pounding six miles up and down a mountain. Toccoa was murderous twenty-mile forced marches done at 130 per minute. Toccoa was where men and officers learned how to take and give orders. But above all Toccoa was the crucible which forged the spirit of this regiment, and where men discovered they could go much further and do much much more than they ever imagined." (Courtesy of the Stephens County Historical Society.)

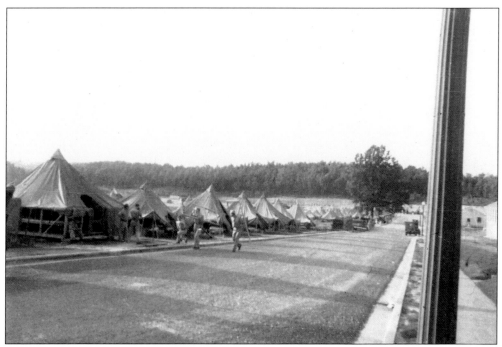

Camp Toccoa was training camp for the 501st, 506th, 511th, and 527th Parachute Infantry Regiments. The main drive through camp is shown here on a typical day. (Courtesy of the Stephens County Historical Society.)

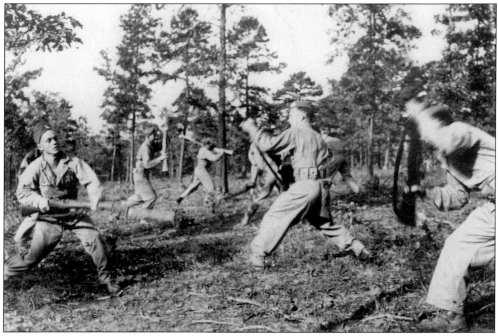

Training was intense, as these soldiers experienced during bayonet class. (Courtesy of the Stephens County Historical Society.)

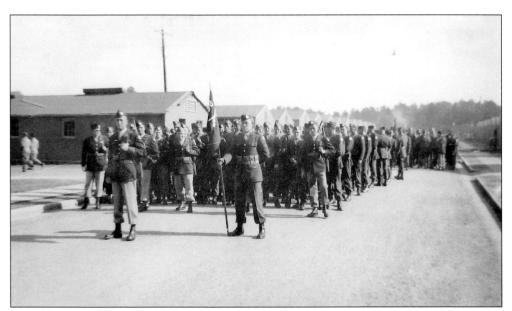

Here, Company G of the 506th musters for inspection in the fall of 1942. The 506th Parachute Infantry Regiment held the high ground on D-Day, defended Bastogne in the Battle of the Bulge, and were later responsible for the capture of Hitler's Eagles Nest outpost at Berchtesgaden. The story of the 506th is told in Stephen Ambrose's book *Band of Brothers* and in the miniseries of the same title. (Courtesy of the Stephens County Historical Society.)

Several soldiers, including Mario J. Patruno, engage in some horseplay at Camp Toccoa. Patruno was 20 years old when he came to Camp Toccoa. He became a paratrooper and was wounded in Holland. He was in service for a year and 10 days. (Courtesy of the Stephens County Historical Society.)

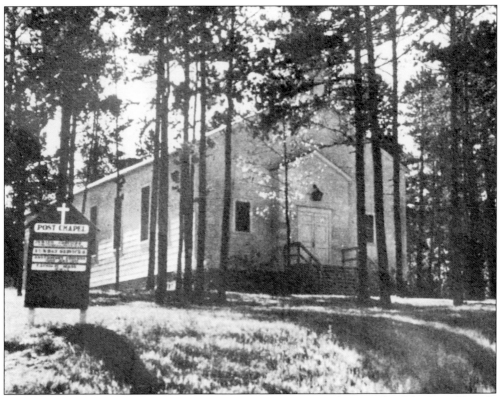

Here is a rare photograph of the Post Chapel at Camp Toccoa on Currahee. (Courtesy of the Stephens County Historical Society.)

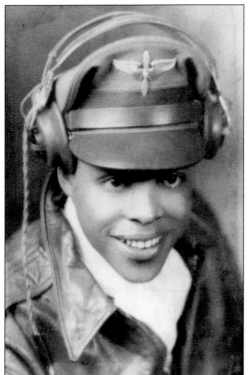

According to the *Toccoa Record*, US Air Force lieutenant colonel LeRoy Roberts Jr., a native Toccoan, was accepted by the Air Force and began his aviation cadet training at the Tuskegee base in Alabama, thereby overcoming prior military racial barriers to become part of the elite Tuskeegee Airmen. Of the nearly 1,000 who won their wings at Tuskegee Army Air Field, 450 were sent over for combat assignment, flying more than 15,000 offensives, destroying more than 1,000 German aircraft and receiving more than 150 Distinguished Flying Crosses. LeRoy Roberts Jr. himself flew 42 missions against the enemy during the war. (Courtesy of the Stephens County Historical Society.)

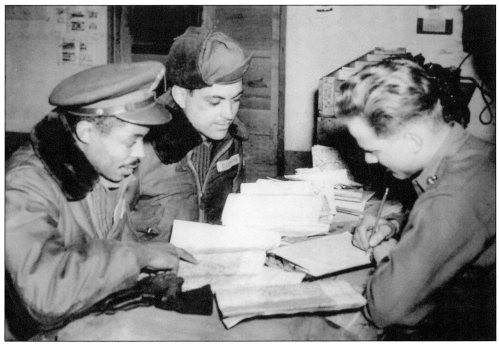

Capt. LeRoy Roberts Jr., on the left, debriefs at a base in Korea after completing his 100th combat mission. (Courtesy of the Stephens County Historical Society.)

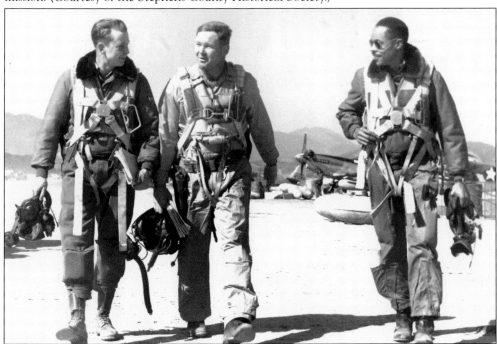

Smiles on the faces of these three Mustang pilots, who have just returned from a combat strike against enemy objectives in Korea, signify the mission was successful. They are, from left to right, 1st Lt. George McKee and Capt. Samuel Sanders, both of Texas, and Capt. LeRoy Roberts of Toccoa. (Courtesy of the Stephens County Historical Society.)

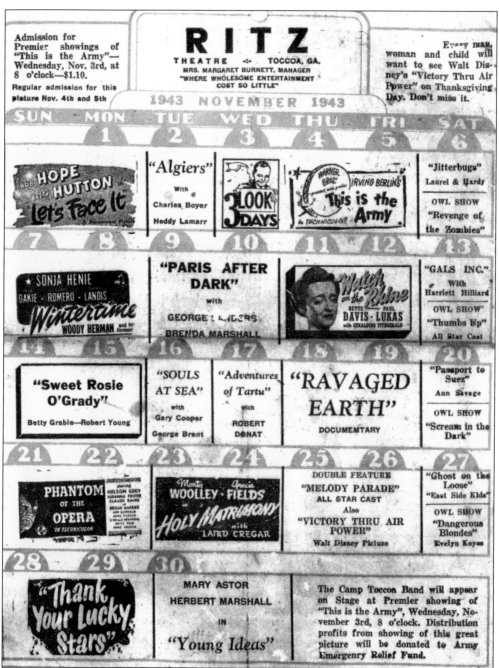

This is a copy of a November 1943 Ritz Theatre program, recently discovered during some apartment renovation, that provides a snapshot into Hollywood's wartime programming. In the lower right is the note: "The Camp Toccoa Band will appear on stage at Premier showing of 'This is the Army,' Wednesday, November 3rd, 8 o'clock. Distribution profits from showing of this great picture will be donated to the Army Emergency Relief Fund. (Courtesy of Kelly Vickers.)

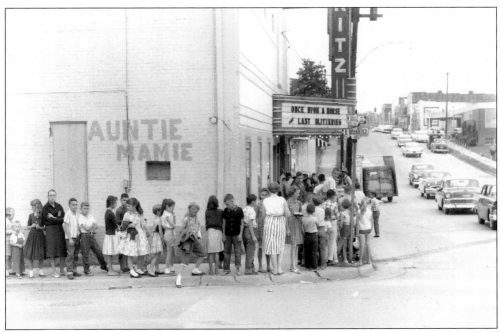

Schoolchildren were kept busy during the summer months waiting in line at the Ritz to see the latest flick. (Courtesy of the Stephens County Historical Society.)

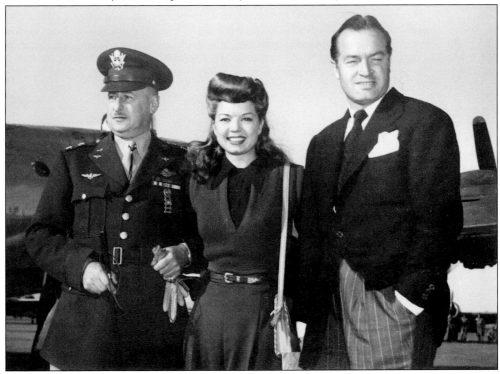

Bob Hope brings his USO show to Toccoa and to Camp Toccoa. In this photograph, singer and performer Frances Langford joins Hope for the show. She was best known as accompanying him on the radio. (Courtesy of the Stephens County Historical Society.)

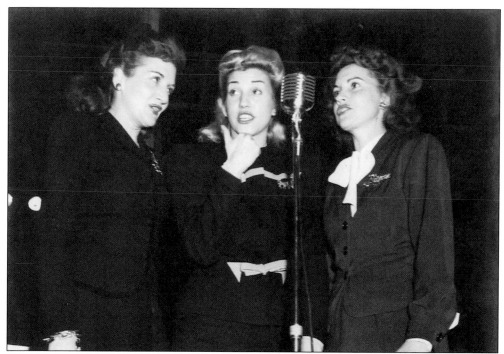

The Andrews Sisters were America's most popular female singing group. In the 1940s, the sisters found themselves in high demand, and became the most profitable stage attraction in the entire nation, earning $20,000 a week. Aside from singing, the sisters were established radio personalities and made appearances in 17 Hollywood movies. Here, the Andrews Sisters perform for the soldiers of Camp Toccoa. (Courtesy of the Stephens County Historical Society.)

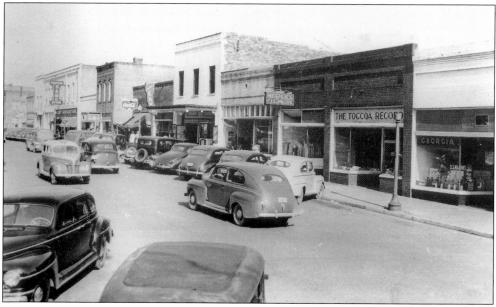

Many a Toccoan caught the latest movie at the Star Theatre on Doyle Street, just left of center with the awning, just a few doors down from the *Toccoa Record*. (Courtesy of the Stephens County Historical Society.)

# STAR THEATRE

## TOCCOA, GEORGIA

### MRS. WINSTON OWEN, MANAGER

More people are seeing the shows at the STAR than ever before. You too will enjoy the action and comedy type pictures. Lots of entertainment for your money.

**MON., TUES., NOV. 1-2**
**DOUBLE FEATURE**
"AVENGING RIDER"
TIM HOLT
Also
"JOE SMITH AMERICAN"
ROBERT YOUNG

**WEDNESDAY, NOVEMBER 3**
"CONEY ISLAND"
WITH BETTY GRABLE

**THURS., FRI., NOV. 4-5, DOUBLE FEATURE**
"LADY BE GOOD"
With
ANN SOTHERN
Also
"NOBODYS DARLING"
MARY LEE

**SATURDAY, NOVEMBER 6**
"SUNDOWN KID"
DON (RED) BARRY

**SUNDAY, NOVEMBER 7**
"THE WEST SIDE KID"
DON BARRY

**MON., TUES., NOV. 8-9**
"FUGITIVES OF THE PLAINS"
BILLY THE KID
Also
"DOWN IN SAN DIEGO"
ALL STAR CAST

**WEDNESDAY, NOVEMBER 10**
"CHINA"
ALLAN LADD, LORETTA YOUNG

**THURS., FRI., NOV. 11-12**
**DOUBLE FEATURE**
"SHADOW OF THIN MAN"
WILLIAM POWELL
Also
"MY SON THE HERO"
PATSY KELLY

**SATURDAY, NOVEMBER 13**
"IDAHO"
ROY ROGERS

**SUNDAY, NOVEMBER 14**
"THE GHOST AND THE GUEST"
James Dunn — Florence Rice

**MON., TUES., NOV. 15-16**
**DOUBLE FEATURE**
"IN OLD MONTEREY"
GENE AUTRY
Also
"YANK ON BURMA ROAD"
ALL STAR CAST

**WEDNESDAY, NOVEMBER 17**
"DESPERADOES"
RANDOLPH SCOTT

**THURS., FRI., NOV. 18-19**
**DOUBLE FEATURE**
"COURTSHIP OF ANDY HARDY"
MICKEY ROONEY
Also
"LADY FROM CHUNGKING"
ANNA MAY WONG, MAE CLARK

**SATURDAY, NOVEMBER 20**
"PARDON MY GUN"
CHARLES STARRETT

**SUNDAY, NOVEMBER 21**
"BOSS OF THE BIG TOWN"
FLORENCE RICE

**MON., TUES., NOV. 22-23**
**DOUBLE FEATURE**
"PRAIRIE THUNDER"
DICK FORAN
Also
"KID GLOVE KILLER"
VAN HEFLIN

**Wednesday, November 24**
"HIT THE ICE"
ABBOTT & COSTELLO

**THURS., FRI., NOV. 25-26**
**DOUBLE FEATURE**
"WHISTLING IN DIXIE"
RED SKELTON
Also
"TOMORROW WE LIVE"
ALL STAR CAST

**SATURDAY, NOVEMBER 27**
"CHEYENNE ROUNDUP"
JOHNNY MAC BROWN

**SUNDAY, NOVEMBER 28**
"MYSTERY OF 13TH GUEST"
HELEN PARRISH, DICK PURCELL

**MON., TUES., NOV. 29-30**
**DOUBLE FEATURE**
"THE RANGERS TAKE OVER"
TEXAS RANGERS
Also
"SUNDAY PUNCH"
WILLIAM LUNDIGAN

This Star Theatre program for November 1943 lists the movies playing that month. (Courtesy of Kelly Vickers.)

Henry Power (center), of the Henry Power Café, spends some time visiting with Pfc. Merton Teasley and Cpl. William Sheysink outside his restaurant across from the train depot in 1943. Henry Power was in the best position to service the soldiers on the train as they came through Toccoa. It is reported he would check the train schedule in advance so that when the troops would come through, he would be prepared with hundreds of hamburgers and sandwiches to sell. (Photograph taken by Alton Adams, nephew of Henry Power, and made available courtesy of Lamar Davis.)

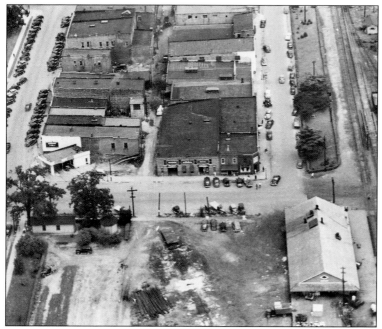

This aerial photograph of downtown Toccoa shows the proximity of the Henry Power Café to the Train Depot, as well as other Toccoa landmarks fixed in time. (Courtesy of the Stephens County Historical Society.)

# Five

# PEOPLE AND PLACES

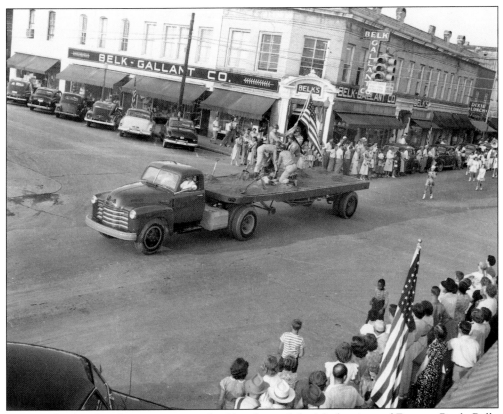

In 1910, this familiar downtown corner building housed the Mechanics and Farmers Bank. Belk-Gallant took it over in 1937. At that time, Toccoa's Belk store was only the 10th in the entire nation. In this Independence Day parade, a float commemorates the capture of Iwo Jima with a reenactment, an event immortalized in Joe Rosenthal's iconic photograph of the raising of the victory flag, for which he received the Pulitzer Prize later in 1945. (Courtesy of the Stephens County Historical Society.)

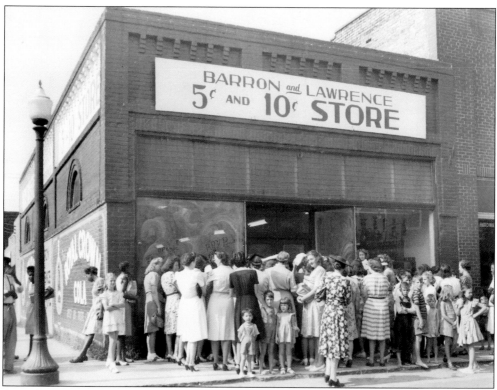

As with many small towns, the general merchandising store was the heart of the community. Stores like Barron and Lawrence (above) offered customers a wide assortment of very affordable household items. Department stores like Green's (below) really knew how to attract customers. (Courtesy of the Stephens County Historical Society.)

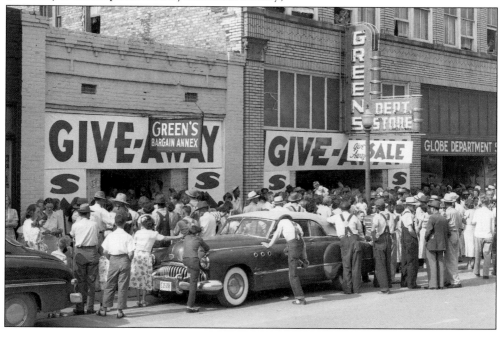

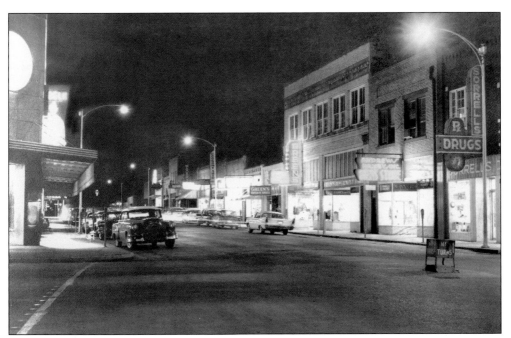

Even at night in the 1940s and 1950s, downtown Toccoa was a place to window shop. Recent revitalization of this area is bringing new life to a city with strong community roots. For some, this photograph should bring back memories of cruising Doyle Street in the evenings. (Courtesy of the Stephens County Historical Society.)

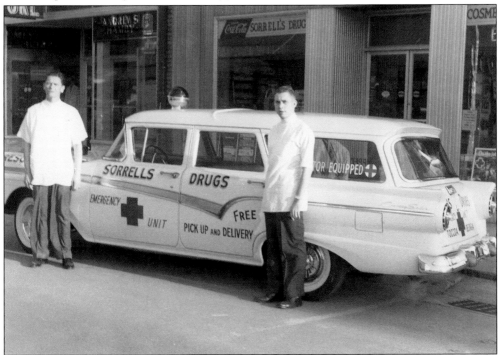

Not only did Sorrells drug store make home deliveries, the owners promised to make free pickups. They also owned an emergency care unit. (Courtesy of the Stephens County Historical Society.)

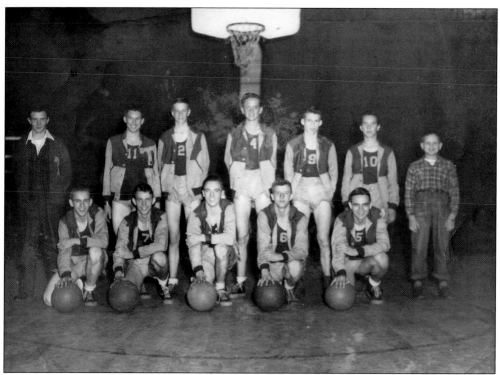

The Toccoa High School basketball team is pictured here around 1947. (Courtesy of Kenneth Martin Heaton.)

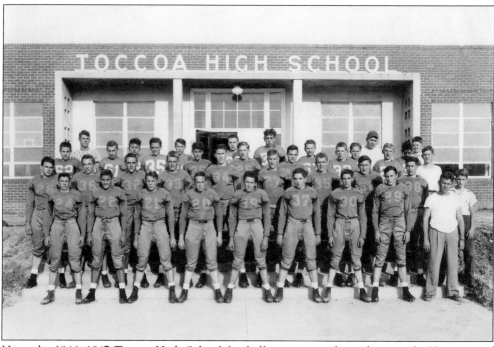

Here, the 1946–1947 Toccoa High School football team poses for a photograph. (Courtesy of Kenneth Martin Heaton.)

The starting lineup for the 1946–1947 Toccoa High School football team poses for their yearbook picture. Starters include Ray Rumsey, Joe Watts, Dick Gross, Darby Smith, Wally Williams, Quentin Merck, W.A. "Dub" Heaton, Troy "Strawberry" Simmons, Buddy Payne, and Bobby Brewer. (Courtesy of Kenneth Martin Heaton.)

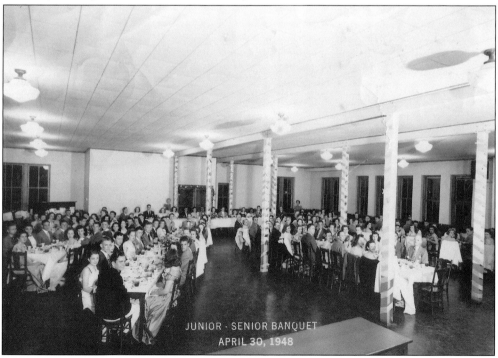

Toccoa High School students gather for the annual Junior-Senior Banquet in April 1948. (Courtesy of Kenneth Martin Heaton.)

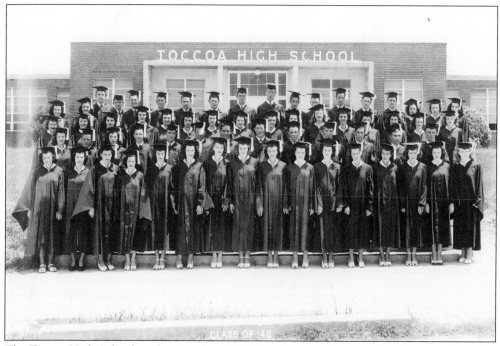

The Toccoa High School graduating class of 1948 gathers together one last time as students for their class photograph. (Courtesy of Kenneth Martin Heaton.)

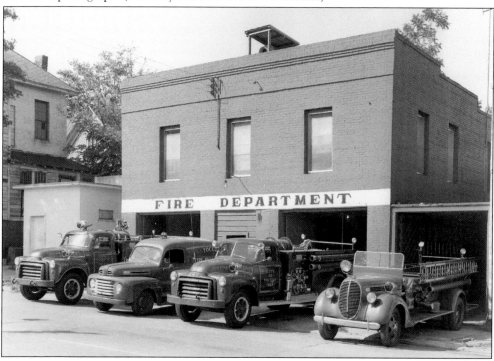

The Toccoa Fire Department shows off its new fire trucks. Immediately to the left of the fire department is the smaller white "calaboose," and behind that can be seen the back of the city hall. (Courtesy of the Stephens County Historical Society.)

Kathryn Trogdon notes in *The History of Stephens County, Georgia* that feed and seed stores offered more than their names indicated, especially in communities like Toccoa where farming was paramount. Barton Claiborn Rothell moved to Toccoa in 1879. He erected a large brick building at the corner of Alexander and Railroad Streets near the railroad depot. The business began as a livery stable and rented horses, buggies, surries, and hacks to salesmen and tourists. With the advent of the car, the business changed to the sale of feed and bulk farm supplies. (Courtesy of the Stephens County Historical Society.)

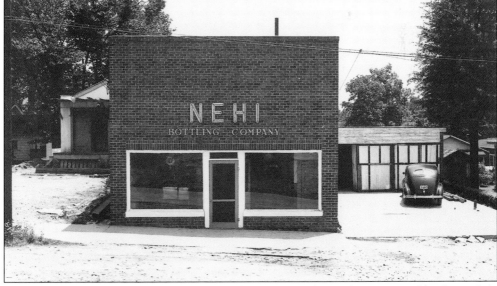

Sodas like Nehi have always had it rough when compared to industry giants like Coca-Cola and Pepsi but thanks to the wonder of small towns and cities, Nehi flourished. The soda drink company was introduced in 1924, and the Nehi Corporation name was adopted in 1928, after the fruit-flavored sodas became popular. In 1955, the company changed its name to Royal Crown Company, after its RC Cola brand, which was also bottled in Toccoa. (Courtesy of the Stephens County Historical Society.)

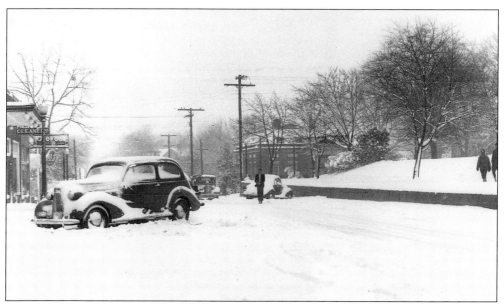

Almost every winter, Toccoa gets a moderate snowfall. In the early years, life and movement around the city was slow and usually ground to a halt. This snowy scene was taken facing the post office (now city hall) west of the courthouse square, looking down Doyle toward Alexander Street. (Courtesy of the Stephens County Historical Society.)

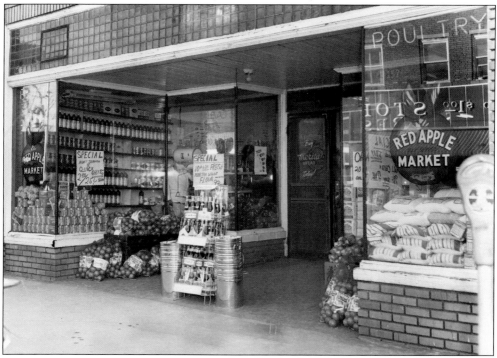

The Acree-Mitchell Red Apple Market was a popular grocery store that had everything—bags of flour (stacked in the window), poultry, eggs, cereal, locally grown vegetables, soft drinks, paper products, and so much more. It was a favorite place to shop in the downtown area. (Courtesy of the Stephens County Historical Society.)

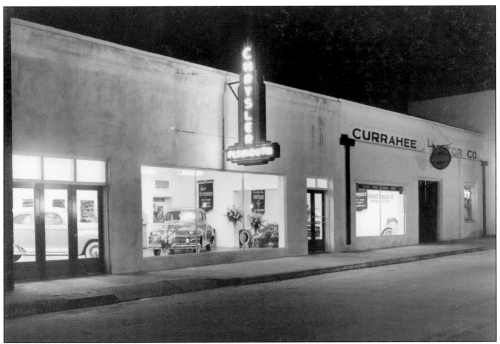

Currahee Motors later became Lawson Motor and Toccoa's Chrysler and Plymouth dealership. Its showroom was always full of the latest models. (Courtesy of the Stephens County Historical Society.)

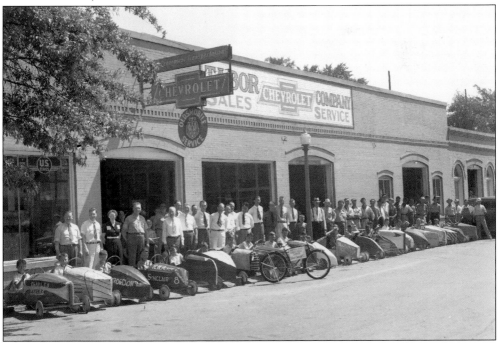

Tabor Company was the city's Chevrolet dealer and always a strong supporter of community events. In this photograph, fathers and sons prepare to race in an annual soapbox derby. (Courtesy of the Stephens County Historical Society.)

The graduating seniors of Whitman Street High School gather for their senior class photograph. Graduates are, from left to right, Leonard Byrd, Charles Shackelford, Fred Pulliam, Betty Burton, Pearlene Nance, George Brown, Miss Crawford, Helen Hickman, Doyle Ogelsby, Melvin Ingram, and Mr. Mayfield. (Courtesy of Willie Mae Byrd Keels.)

This is the first graduating class from Whitman Street High School in 1953. (Courtesy of the Stephens County Historical Society.)

Bobby Byrd, a native Toccoan, was a singer, pianist, songwriter, and performer. He founded the Famous Flames, and found himself catapulted into a three-decade-long successful recording and performing career. He is also credited with enabling James Brown to find success and has been dubbed by some as "the godfather's godfather." (Courtesy of Willie Mae Byrd Keels.)

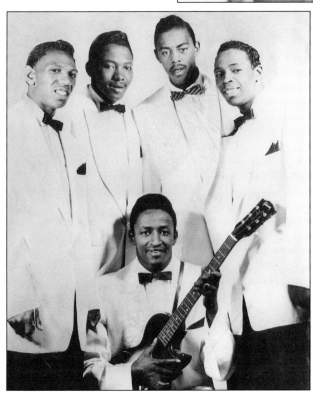

The Famous Flames from Toccoa, from left to right, are Bobby Byrd (founder), Nashspendle Knox, Nafloyd Scott (with guitar), Sylvester Keels, and Johnny Terry. (Courtesy of Willie Mae Byrd Keels.)

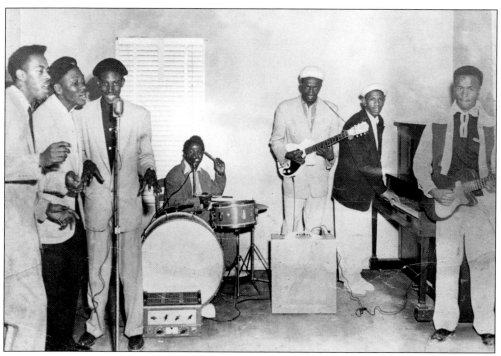

James Brown and the Original Flames practice for their next performance. From left to right are Sylvester Keels, Nashspendle Knox, Fred Pulliam, James Brown on the drums, Nafloyd Scott, Bobby Byrd on piano, and Roy Scott. Not pictured is Original Flame member Johnny Terry. (Courtesy of the Stephens County Historical Society.)

FRANKLIN DISCOUNT 1952 # 870507

Franklin Discount Company began in 1941 as a loan and investment company located on Doyle Street. Organizers of the company were Ben F. Cheek Jr. and J.B. McMurray. The success of their business has been partially attributed to hiring locally. (Courtesy of the Stephens County Historical Society.)

Historically, Toccoa has been a city where people liked to shop in the downtown area. One of the most popular stores for women was the Martha Parks Dress Shop. Customers were known by name. They also had the advantage of being able to purchase the latest designs in a hometown atmosphere where the customer always came first. Their showroom windows were always quick to catch the eye. (Courtesy of the Stephens County Historical Society.)

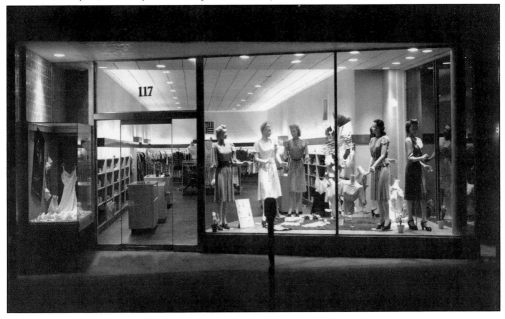

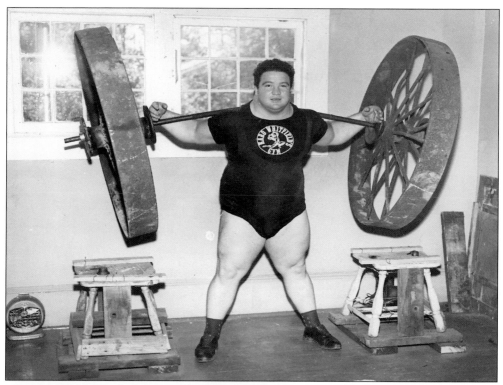

Native Toccoan Paul Anderson trains in his home on Tugalo Street with materials he obtained from scrap metal yards. He records in his book *A Greater Strength* that he did not take an active interest in weightlifting until his freshman year in college. Yet within three years, Anderson was consistently winning competitions. (Courtesy of Paula Anderson Schaefer.)

Wins in both Munich and Moscow in 1955 set young Anderson on his way to win the Olympic gold in Melbourne, Australia, the following year. With this success, however, he remained focused on his relationship with God and used his strength and talents to speak to youth across the country, as well as founding the Paul Anderson Youth Home in Vidalia, Georgia. The Youth Home has made a real difference in the lives of over 1,500 troubled youth. (Courtesy of Paula Anderson Schaefer.)

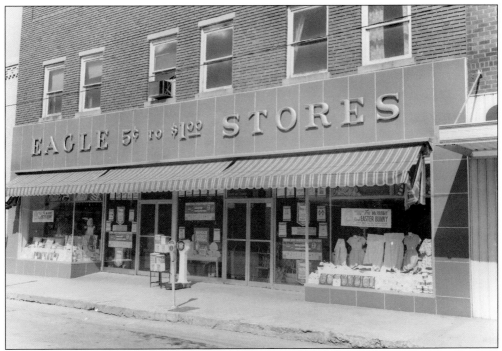

In the first half of the 20th century, Toccoa's main street, like most every town and city in the United States, featured a "dime store." These stores were the first place many people went to look for basic merchandise of all sorts. The Eagle was more like a Woolworth store, in that it offered a broader range of merchandise at affordable prices. (Courtesy of the Stephens County Historical Society.)

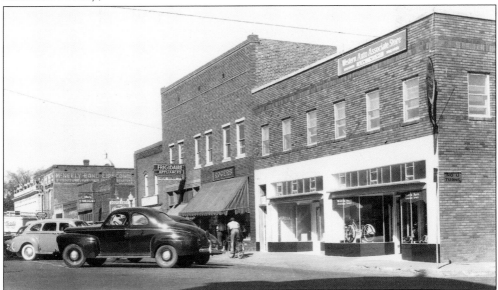

If you could imagine owning it, you could find it in Toccoa. This photograph shows the variety of stores in the downtown area. There was a Western Auto store, Gilberts Drugs, Doots Café, and Ramsey Hardware, which offered a line of Frigidaire appliances. Note the top of the Stephens County Courthouse in the background. (Courtesy of the Stephens County Historical Society.)

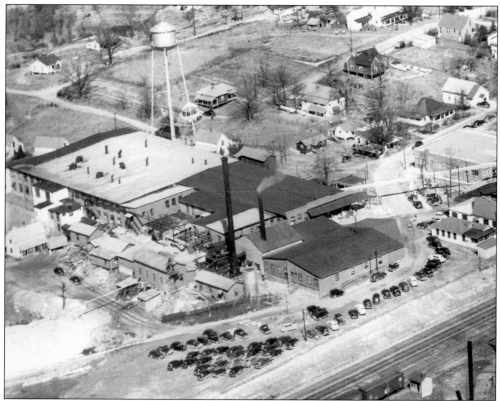

T.A. Capps built the second cotton mill in Toccoa, which was purchased by J. and P. Coats in 1937. J. and P. Coats eventually became Coats and Clark Inc. and was one of the city's most popular employers. These photographs provide perspective on the breadth of the Coats and Clark campus. (Courtesy of the Stephens County Historical Society.)

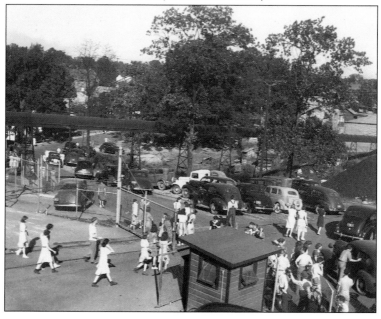

The Citizen's Bank began operation in Toccoa in 1950. Each stockholder was limited to only $5,000 worth of stock. The first president of the bank was Ray Trogdon, with Wallace B. Bruce serving as manager. (Courtesy of the Stephens County Historical Society.)

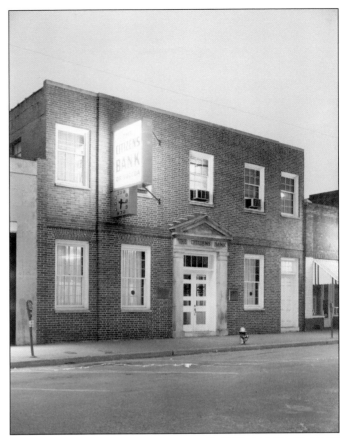

By 1960, Toccoa had several grocery stores: Big A Supermarket, Carters Superette, Colonial Stores, Arch Crump's Pack and Pay Grocery, Ertzberger's Superette, Mullinax Grocery, Sheriff's Foodland, and Winn-Dixie. Colonial Stores, pictured here, was managed by Ed Elrod. (Courtesy of the Stephens County Historical Society.)

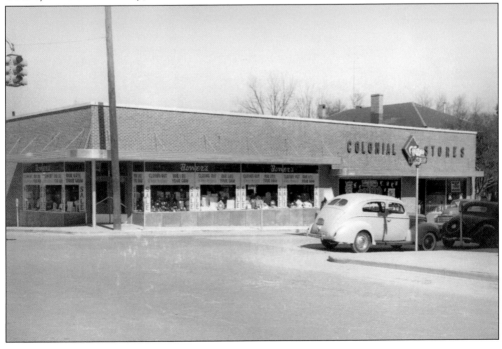

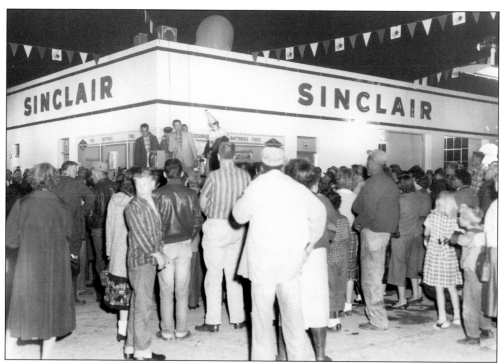

Acree Oil Company opened its new Sinclair Service Station in 1958 and attracted quite a large crowd. (Courtesy of the Stephens County Historical Society.)

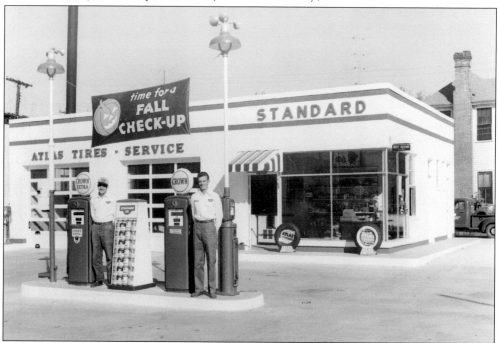

For years, Joel Gross operated the Standard Oil gasoline business in Toccoa. The one pictured here was a popular service station located on Tugalo Street. (Courtesy of the Stephens County Historical Society.)

Although Hoods Furniture specialized in home furnishings, they also offered a complete line of electrical appliances. Hoods was located on Sage Street. (Courtesy of the Stephens County Historical Society.)

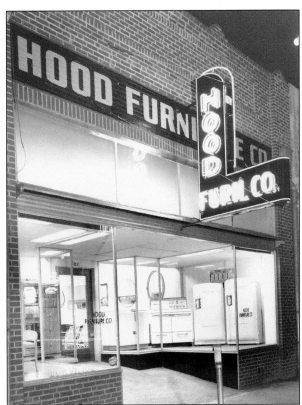

Tommy Lee "Doc" Scott was one of Toccoa's most well known personalities. He was the son of Clifton Swinton and Lizzie Collins Scott of Eastanollee. He was a talented artist, singer, songwriter, performer, and a ventriloquist. Doc Scott was accomplished in multiple genres of music, including country, honky tonk, rockabilly, and bluegrass. He performed regularly for radio stations, including WTFI in Toccoa Falls and WAIM in Anderson, South Carolina. Here, Scott is seen with CBS News reporter Charles Kuralt on one of his tours. (Courtesy of the Stephens County Historical Society.)

Ella Cooper Garner was one of Georgia's first women to host her own radio show, "The Scrapbook Hour," heard on WTFI. Mrs. Garner also had a regular column in the *Toccoa Record* that was followed closely and loved by all. She was also locally known as the "Scrapbook Lady." Here, she is interviewing Rep. Phil Landrum and Ben F. Cheek Jr., prominent Methodist layman, civic leader, and financier. (Courtesy of the Stephens County Historical Society.)

Pinkie Craft Ware, popular educator, musician, author, and community leader extraordinaire, was daughter of the late Reverend and Mrs. A.C. Craft, founders of the Toccoa Orphanage and School. Founded in 1911, the orphanage cared for more than 1,400 children over a period of 30 years in the downtown area, closing in 1941. In 1958, a simple monument was dedicated on the courthouse square in appreciation to Dr. and Mrs. Craft and their family. (Courtesy of the Stephens County Historical Society.)

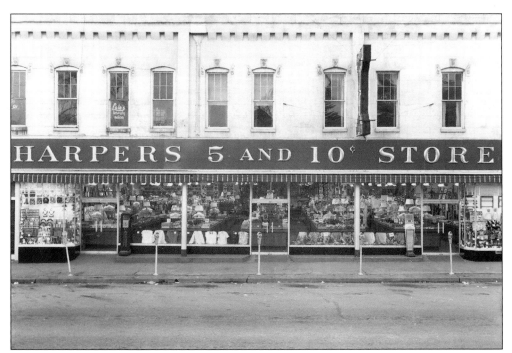

For more than 30 years, this historic building was home to the Harpers Five and Dime. It was a department store that is long remembered by many Toccoa shoppers. (Courtesy of the Stephens County Historical Society.)

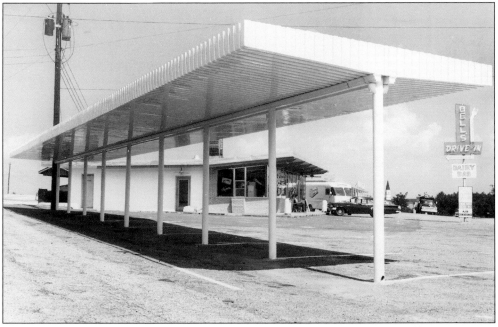

Ask anyone who has grown up in Toccoa and you will hear a story about Bell's. For years, it has been the place where people have met after church on Sunday, for high school events, including football and basketball games, and business lunches. (Courtesy of the Stephens County Historical Society.)

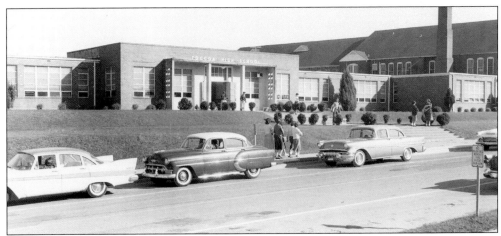

Recalling many great memories, Toccoa High School appears here in 1958. (Courtesy of the Stephens County Historical Society.)

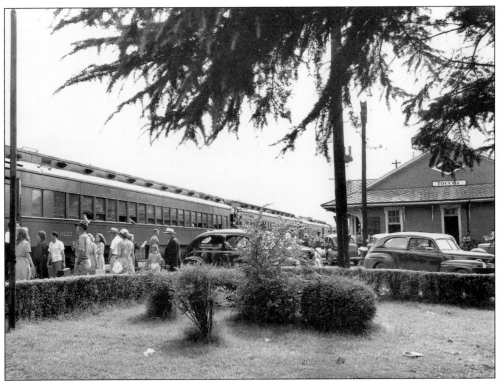

This brief pictorial history closes with a 1950s photograph recalling the coming of the railroad, which first helped to put Toccoa on the map. (Courtesy of the Stephens County Historical Society.)

# BIBLIOGRAPHY

Anderson, Paul. *A Greater Strength*. Old Tappan, NJ: Fleming H. Revell Company, 1975.

Bouwman, Robert Eldridge. *Traveler's Rest and the Tugaloo Crossroads*. Atlanta: State of Georgia, Department of Natural Resources, 1980.

Damron, Troy. *A Tree God Planted: The Story of Toccoa Falls College*. Toccoa Falls, GA: Toccoa Falls College, 2006.

Evans-Shumate, Patti and Rebecca Bruce, and Cora Brady Ledbetter. *Life Along the Middle Broad River and Happenings around Leatherwood Mountain in the Early 1900s*. 2011.

Fant Jr., David J. *Ambassador on Rails: David J. Fant Engineer Evangelist*. Harrisburg, PA: Christian Publications, 1968.

Foster, K. Neill. *Dam Break in Georgia: Sadness and Joy at Toccoa Falls*. Camp Hill, PA: Horizon House Publishers. 1978.

Hayes, Channing P. *The Tugaloo Anthology*. Merritt Island, FL: Sea Haze Publications, 1995.

Howell, Sue Craft and Pinkie Craft Ware. *The House of Many Rooms: History of Toccoa Orphanage and Its Founders*. Toccoa, GA: Currahee Printing, 1991.

Law, Tom, ed. "Gridiron Gallery: Toccoa-Stephens County Football 1948–2008." The *Toccoa Record* Archives. 2009.

Moothart, Lorene. *Achieving the Impossible With God: The Life Story of Dr. R.A. Forrest*. Toccoa Falls, GA: Toccoa Falls College, 2006.

Stephens County Historical Society, ". . . Of Time and Place: A Presentation by the Stephens County Historical Society Inc." 1984.

Stephens County Historical Society. *Stephens County, Georgia, and Its People, Vol. I*. Waynesville, NC: Don Mills, 1996.

Trogdon, Kathryn Curtis. *The History of Stephens County, Georgia*. Toccoa, GA: Toccoa Woman's Club Inc. 1973.

# DISCOVER THOUSANDS OF LOCAL HISTORY BOOKS FEATURING MILLIONS OF VINTAGE IMAGES

Arcadia Publishing, the leading local history publisher in the United States, is committed to making history accessible and meaningful through publishing books that celebrate and preserve the heritage of America's people and places.

## Find more books like this at
## www.arcadiapublishing.com

Search for your hometown history, your old stomping grounds, and even your favorite sports team.

Consistent with our mission to preserve history on a local level, this book was printed in South Carolina on American-made paper and manufactured entirely in the United States. Products carrying the accredited Forest Stewardship Council (FSC) label are printed on 100 percent FSC-certified paper.

MADE IN THE

USA